Pets On Kaleidoscope

High Contrast Kaleidoscopic Photos Of Our Pets To Color

ERIKA S. CLARK

This book is for all the people out in the world who love to express their individualism.
Those who wear what they want, talk as they please, and show confidence in all aspects of their wicked awesomeness make the world more colorful.
This is also dedicated to our dogs and cats,
without them none of the contents would not have become...and that opossum.
It is their photos that got tweaked to fill these shading pages.
And also to all the nice and brave people who will stand up for others.
Being bullied is no fun.
Adopt a pet for their lifetime.

Copyright © 2012 Erika S. Clark

All rights reserved.

ISBN: 1535367121
ISBN-13: 978-1535367127

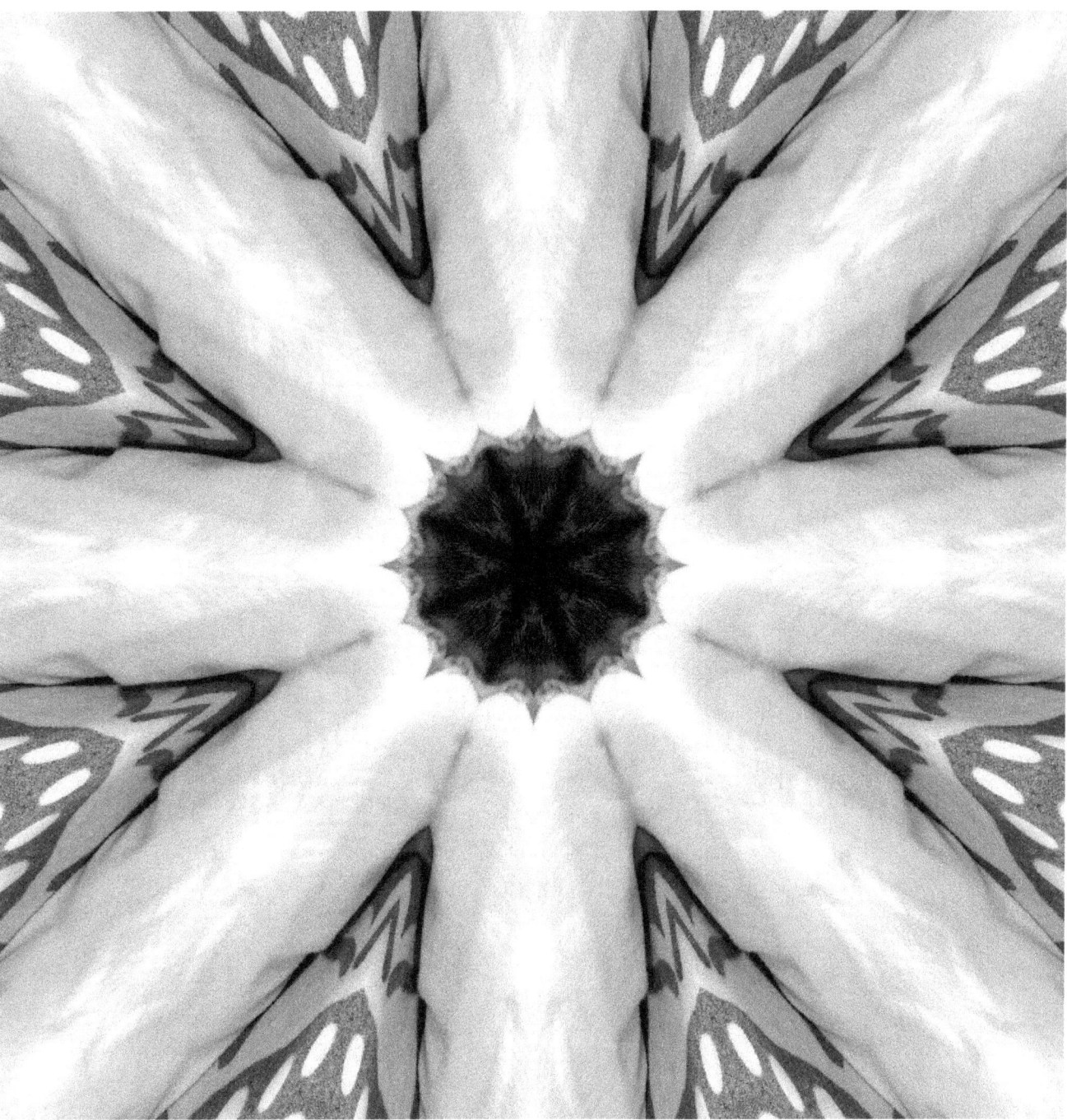

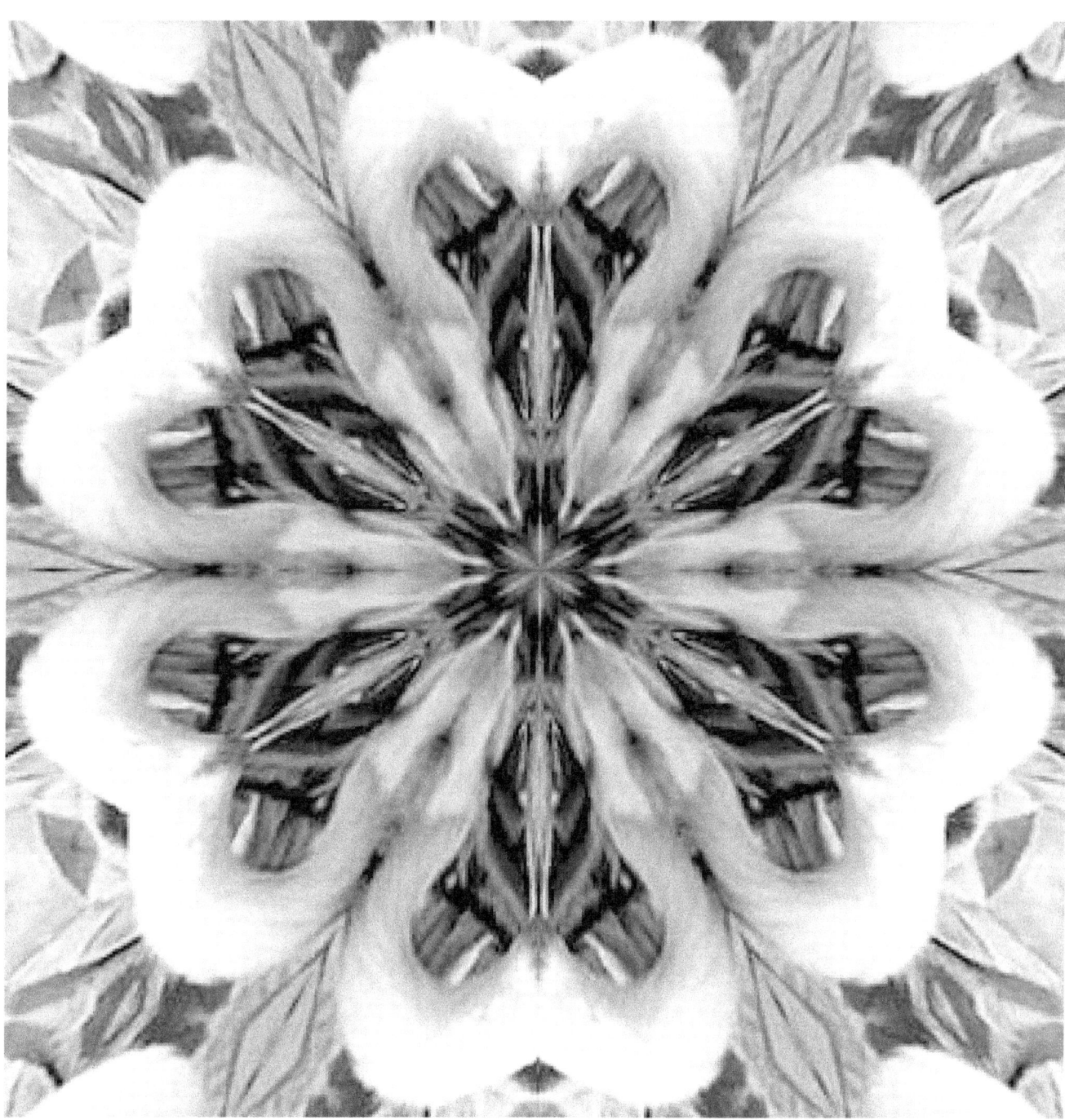

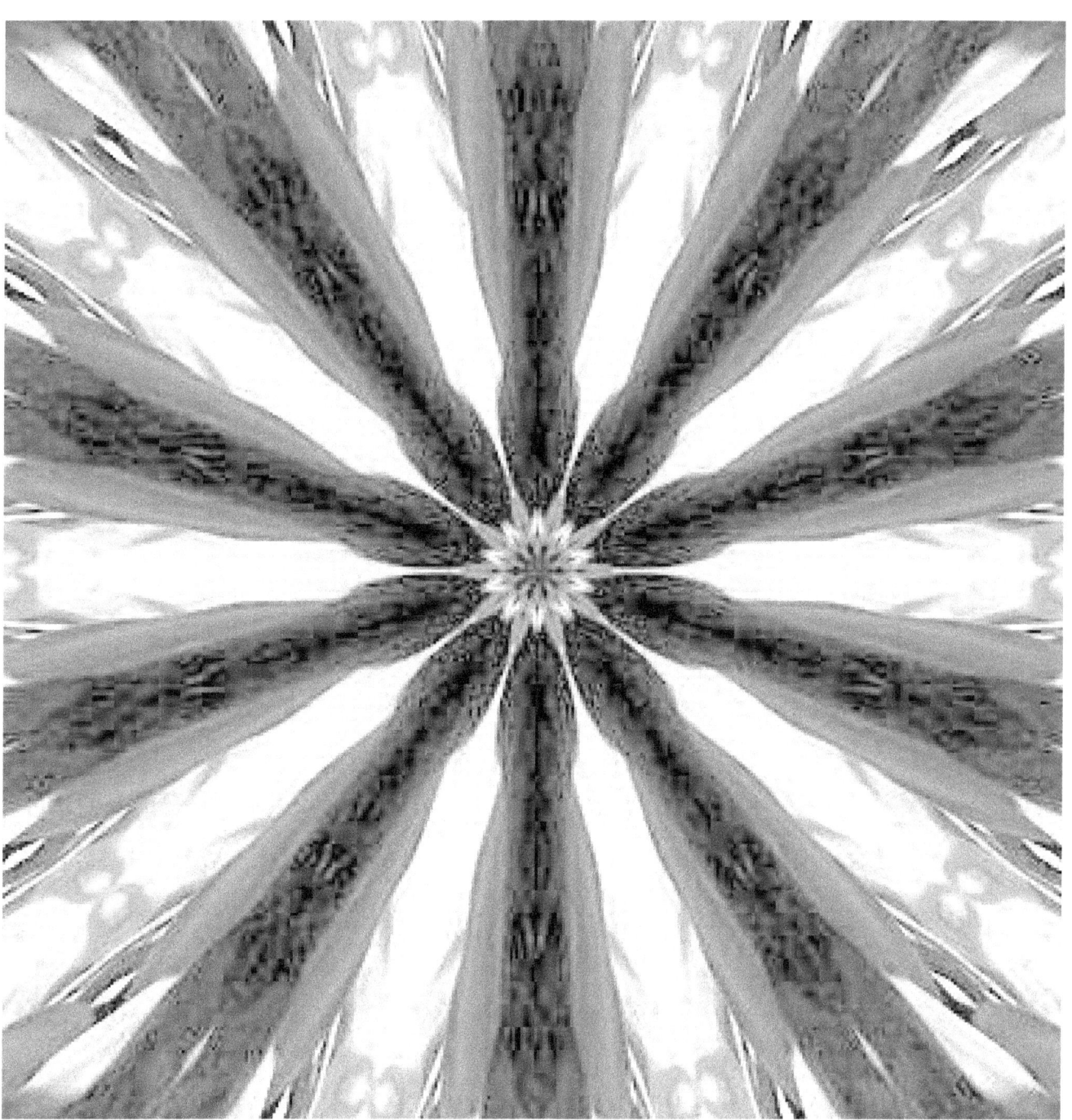

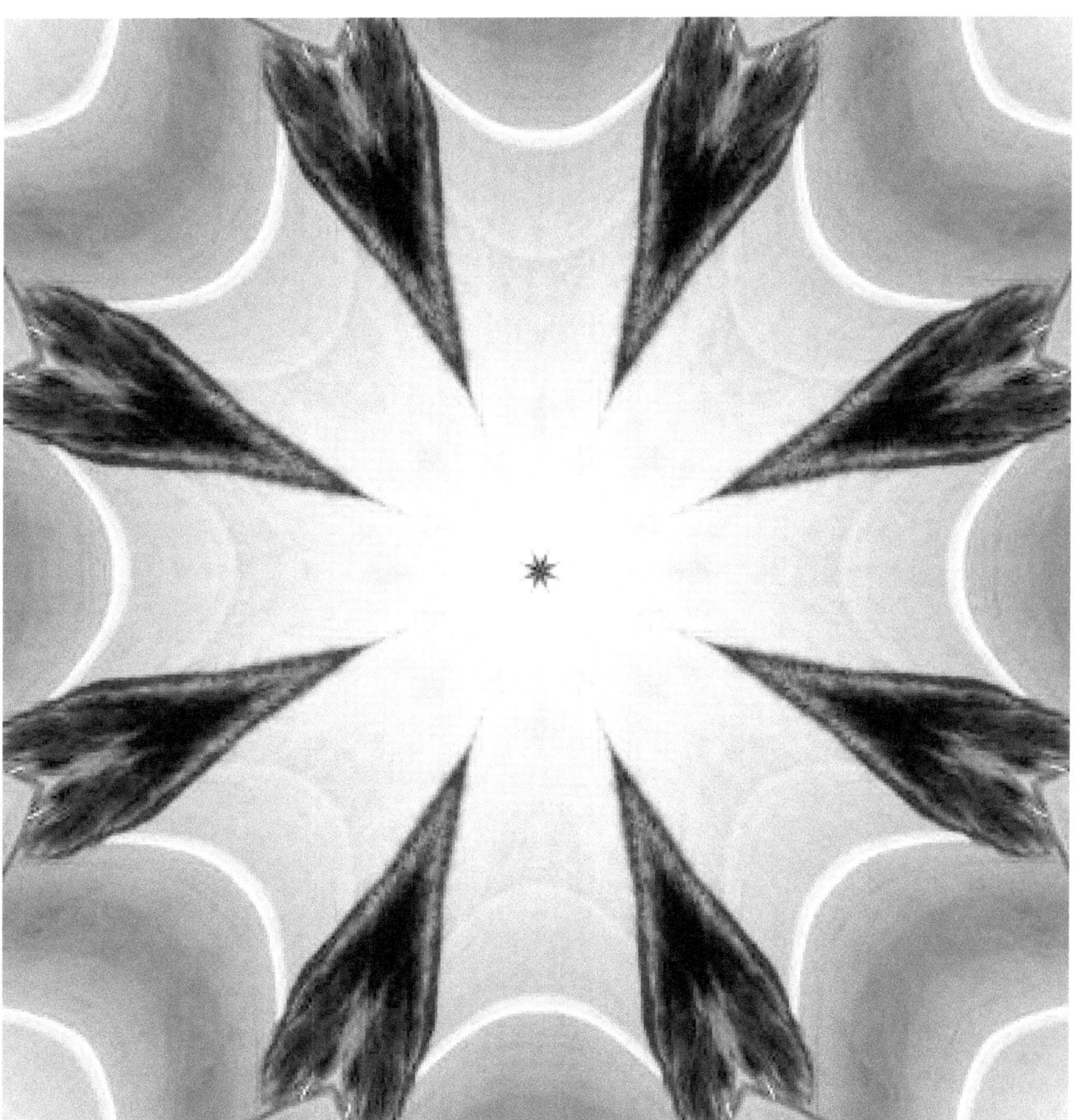

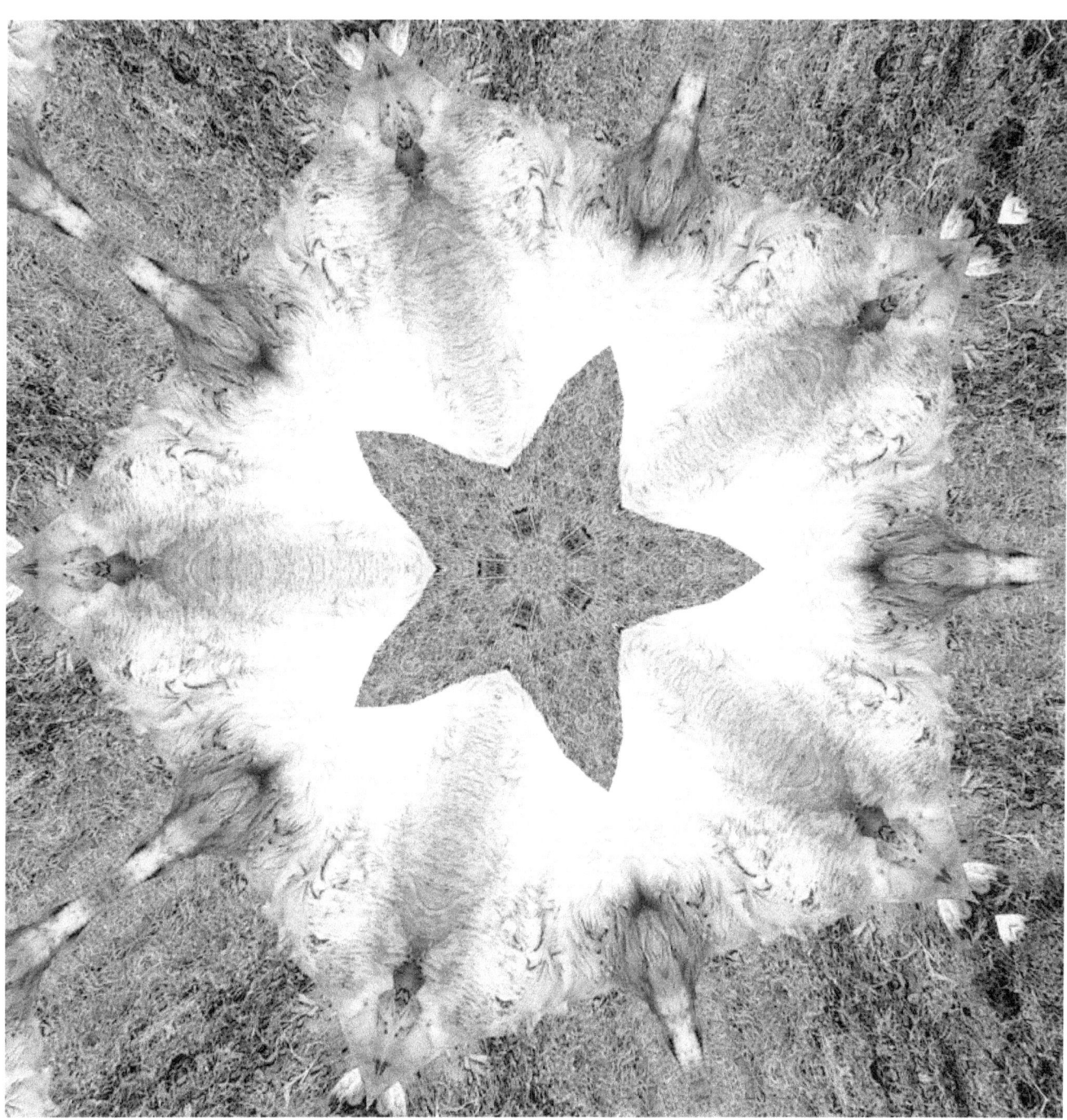

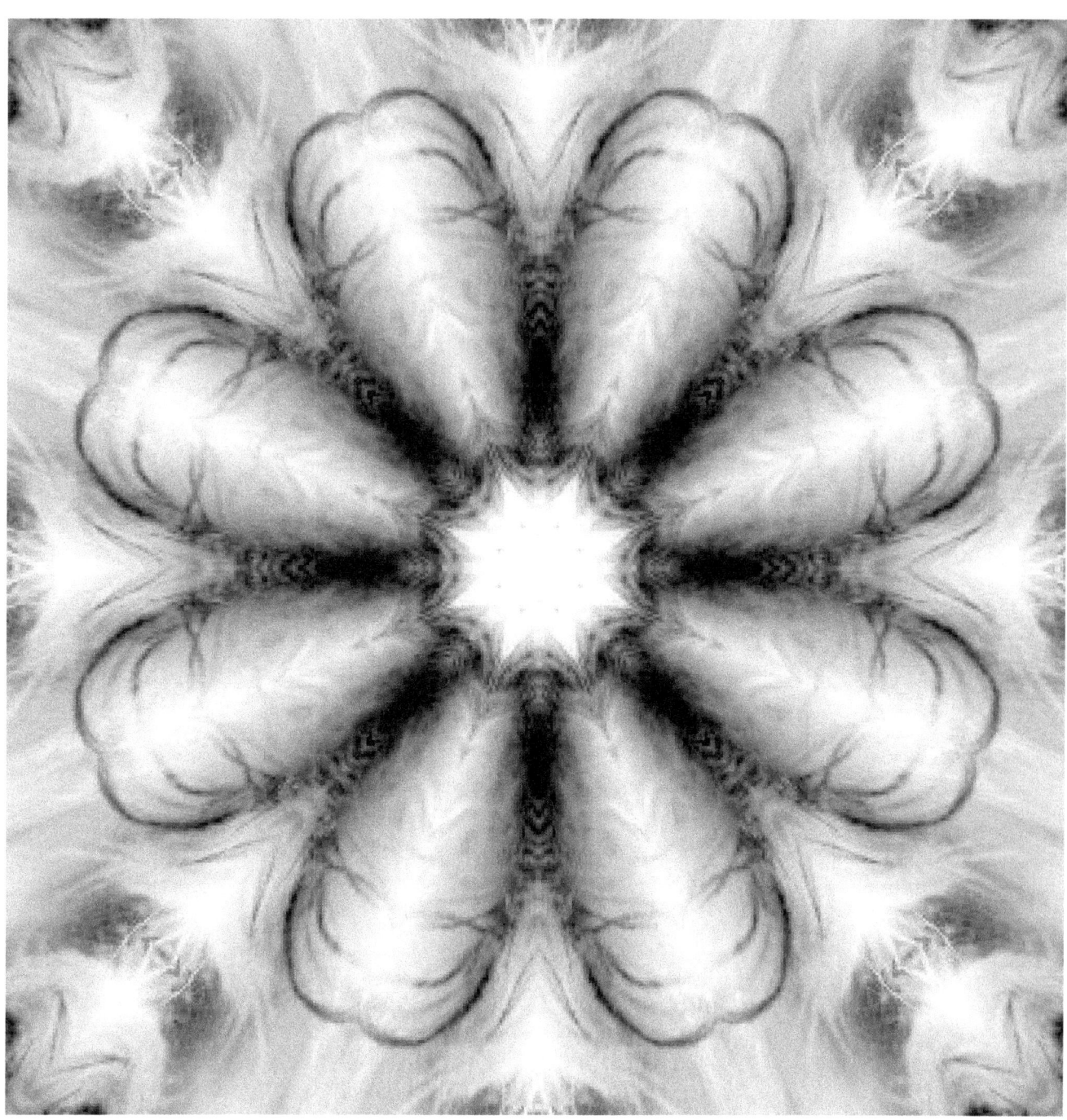

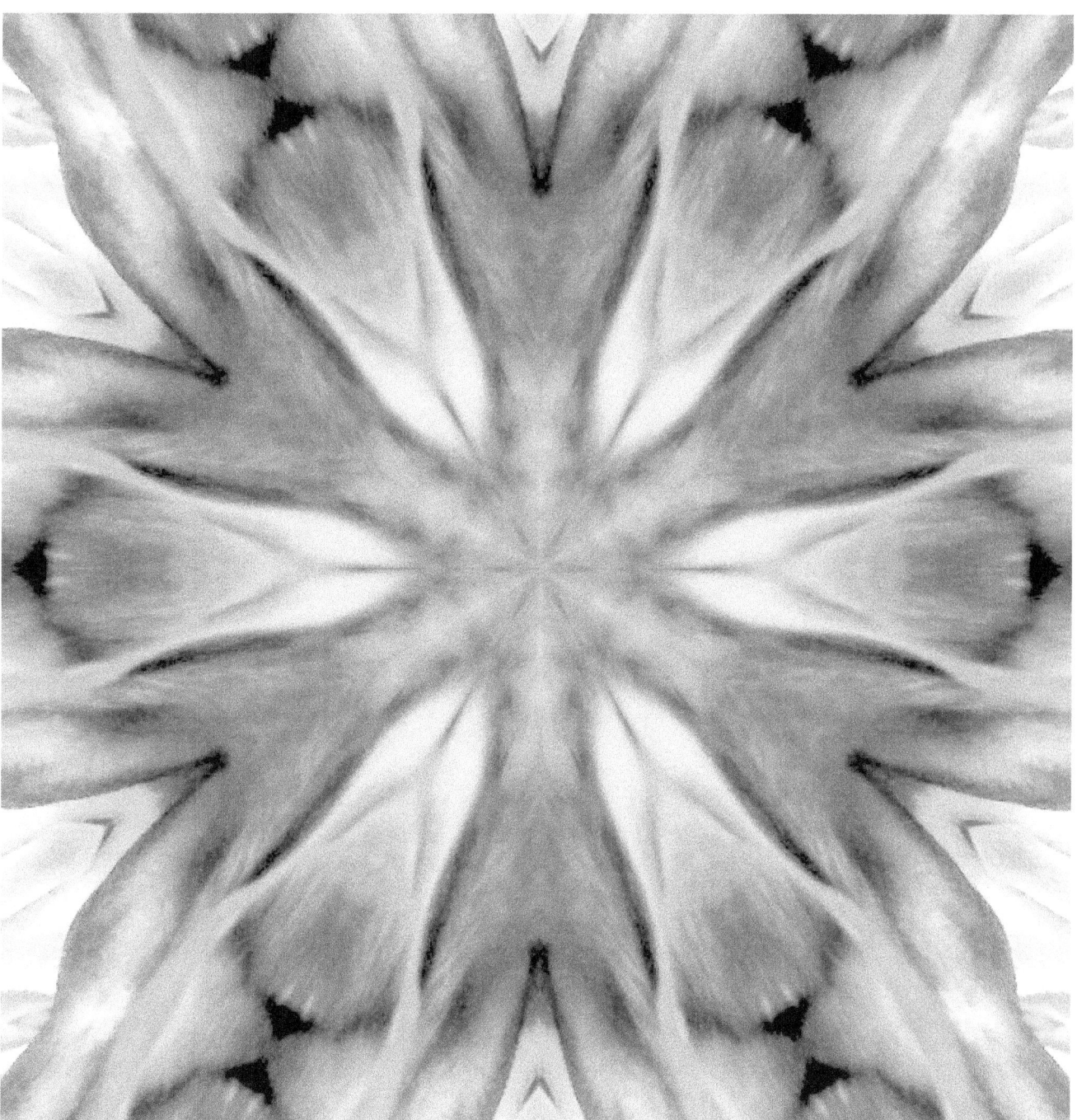

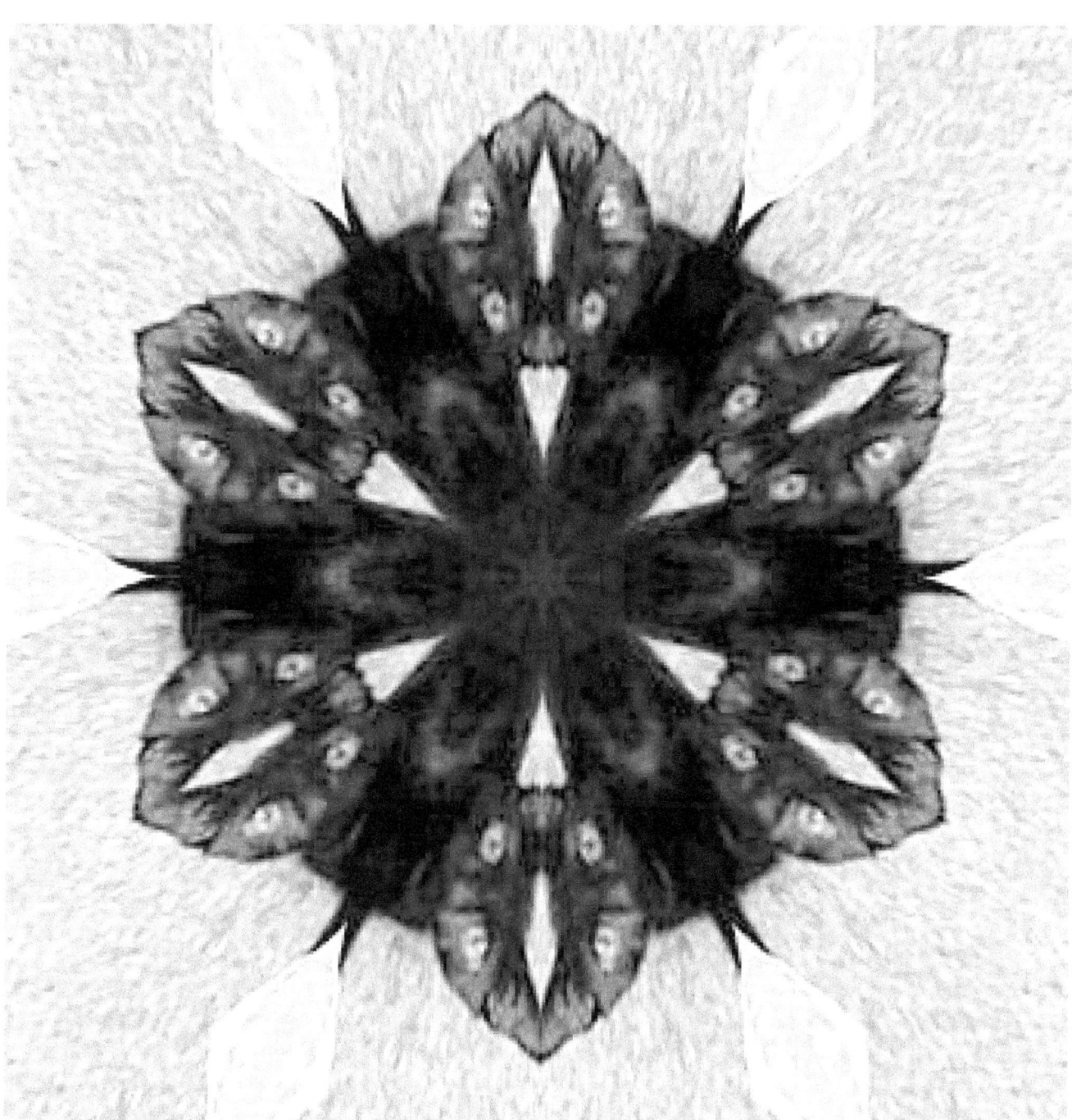

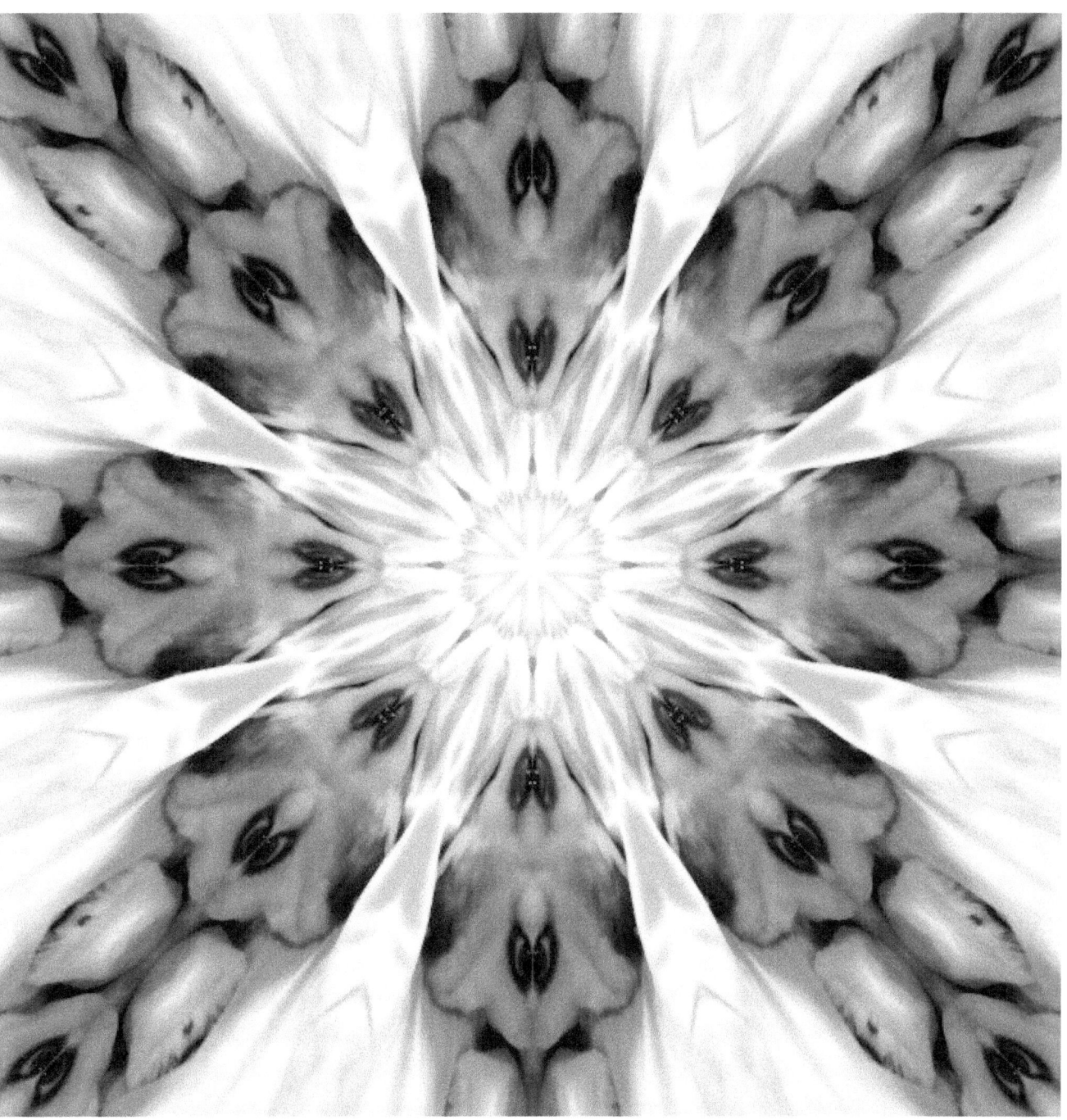

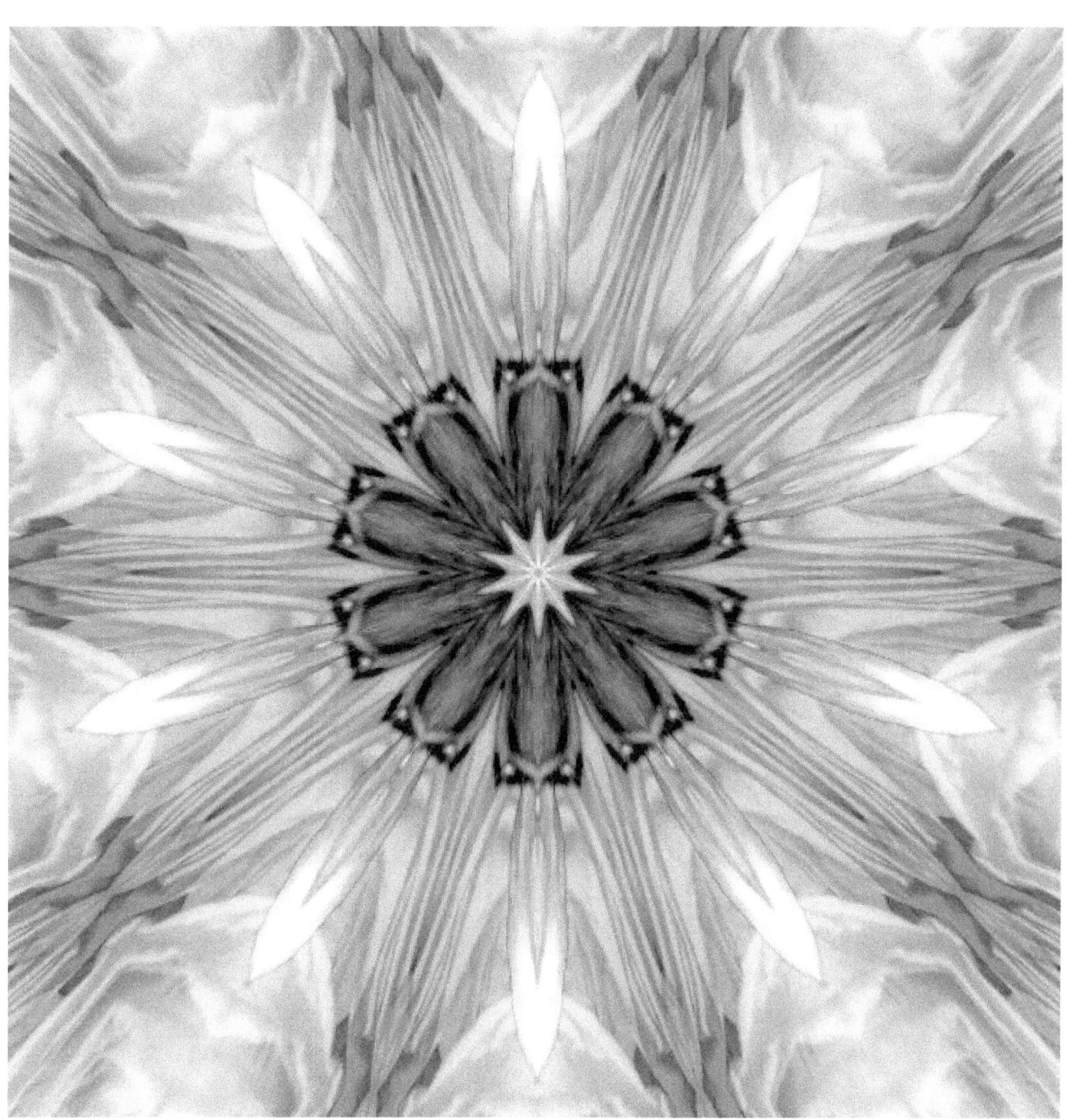

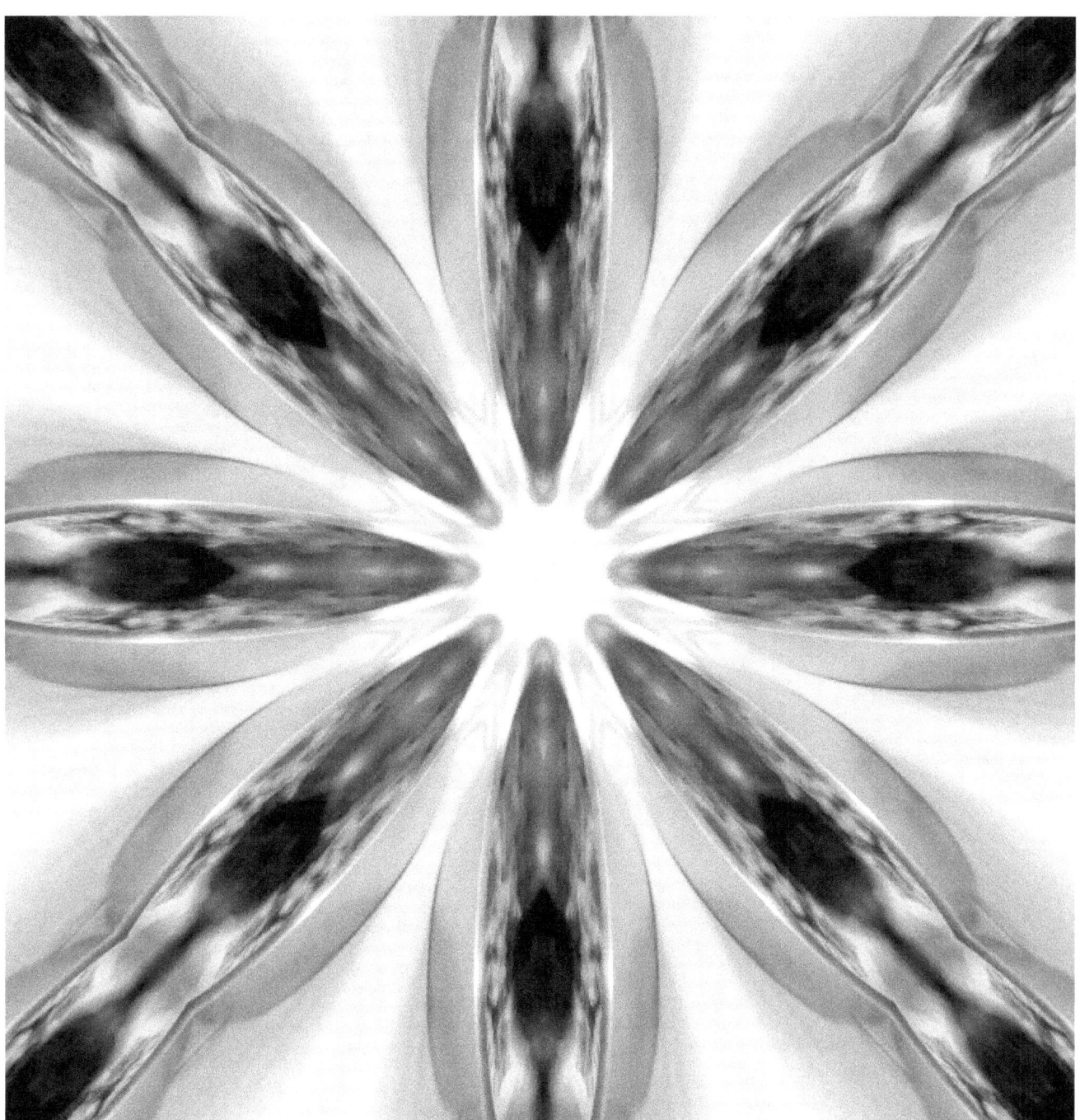

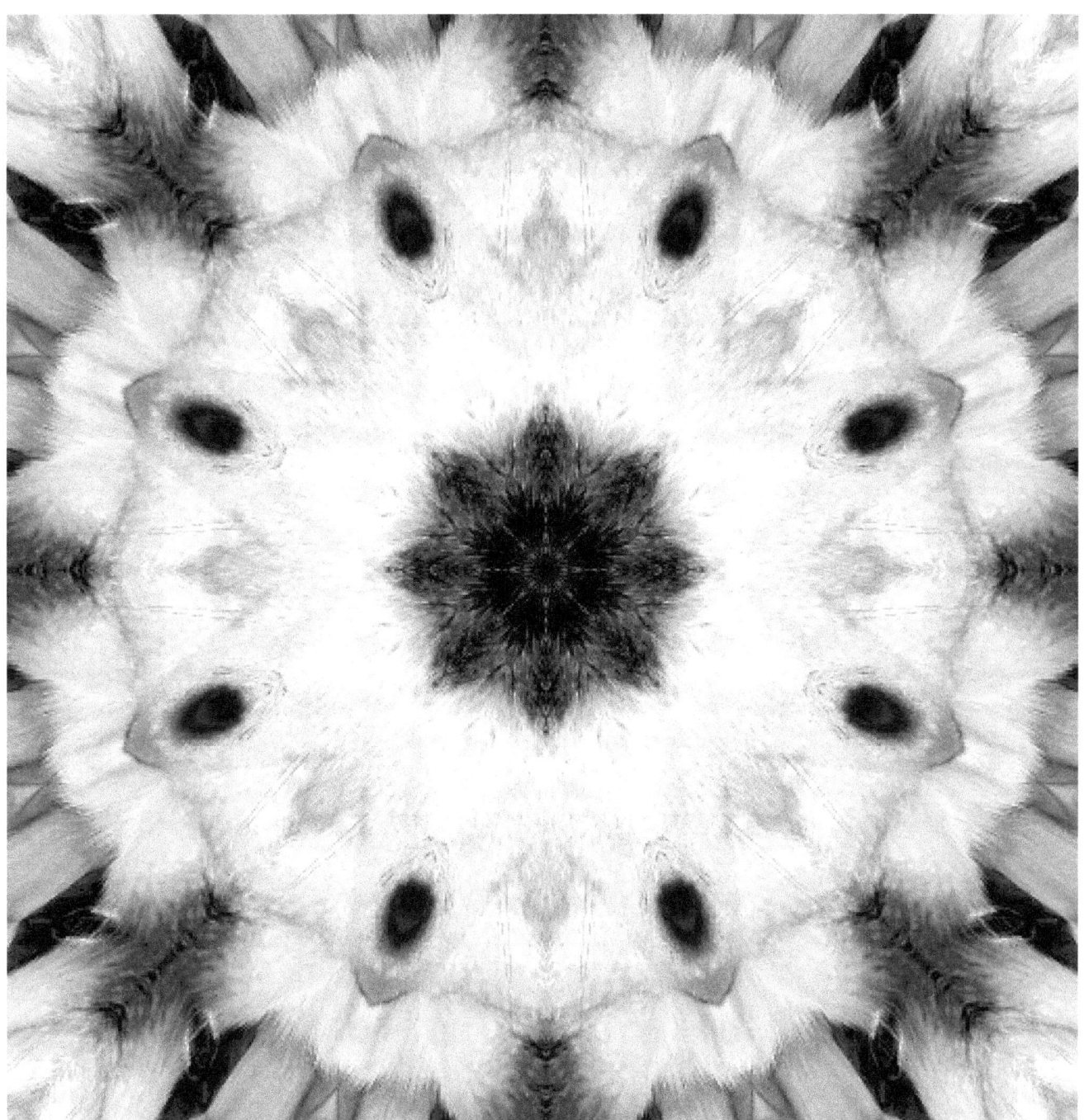

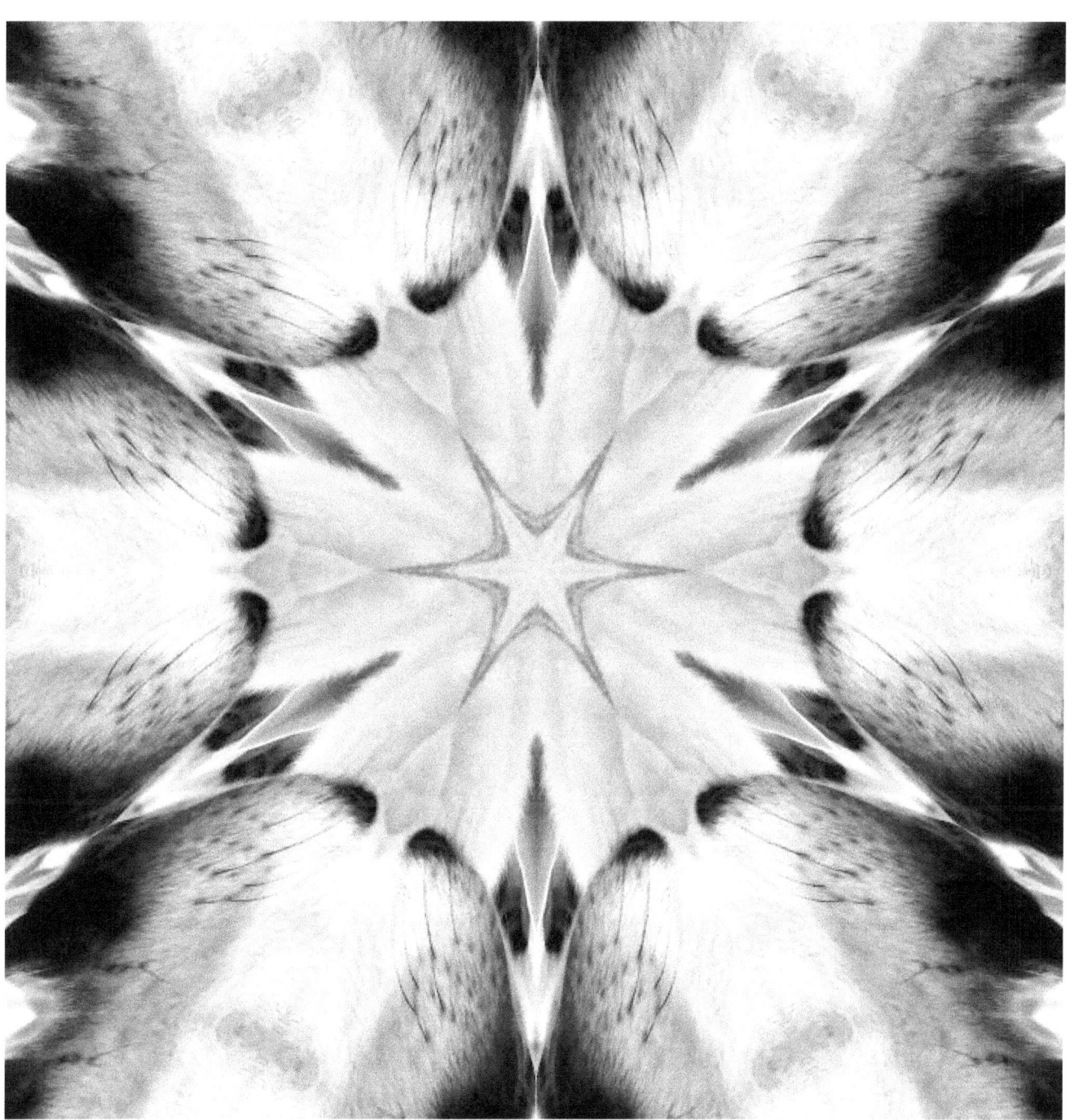

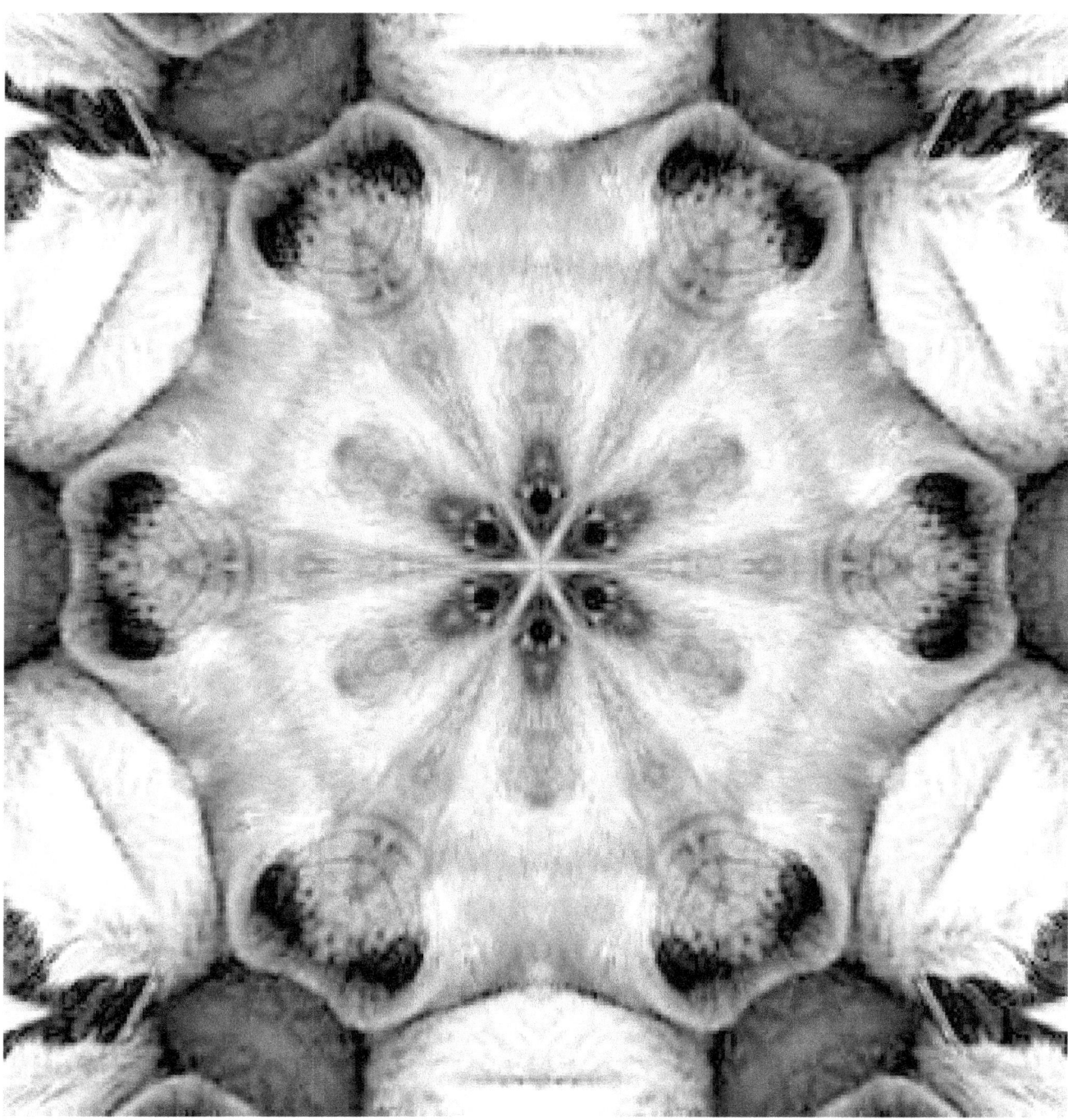

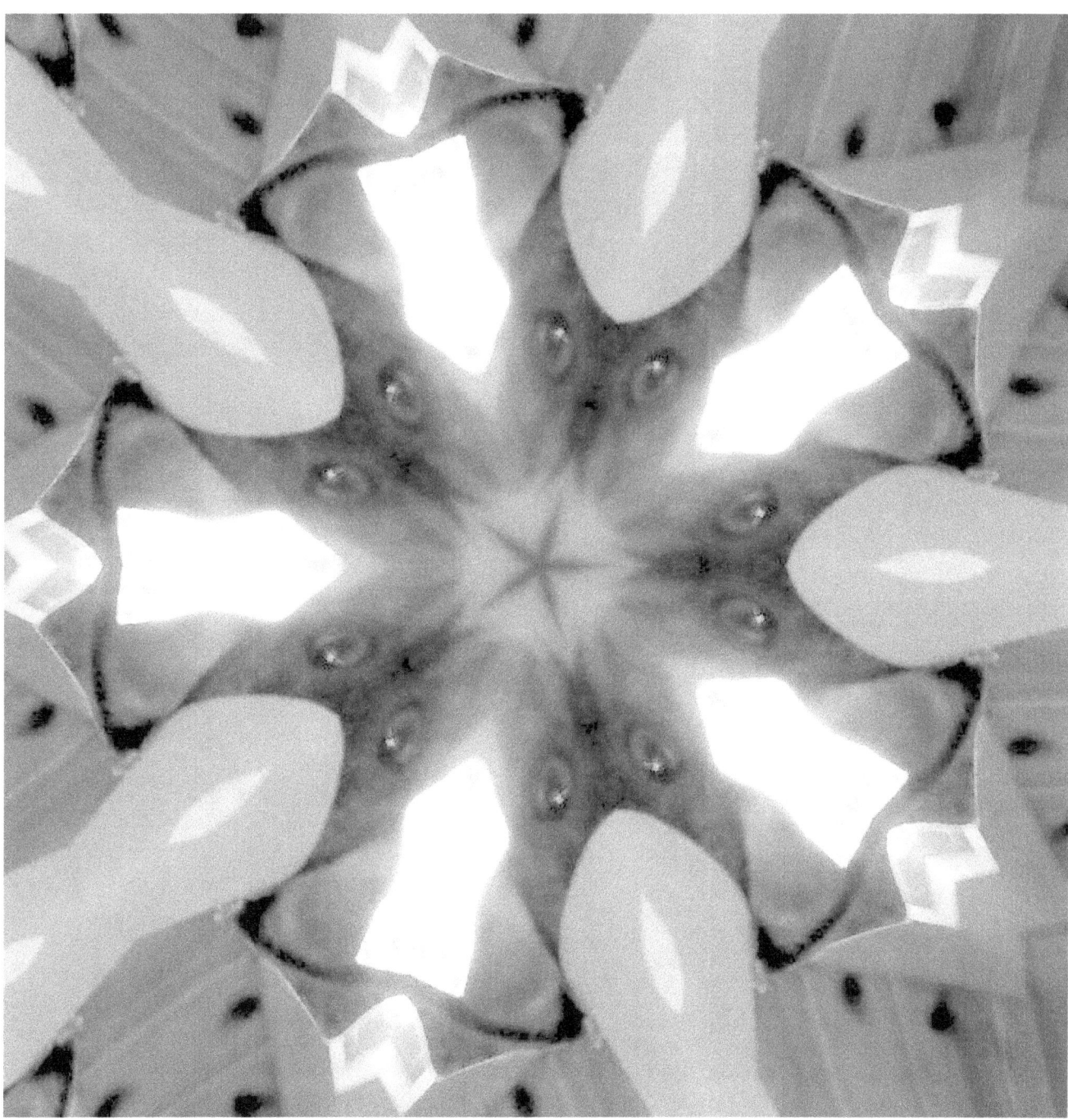

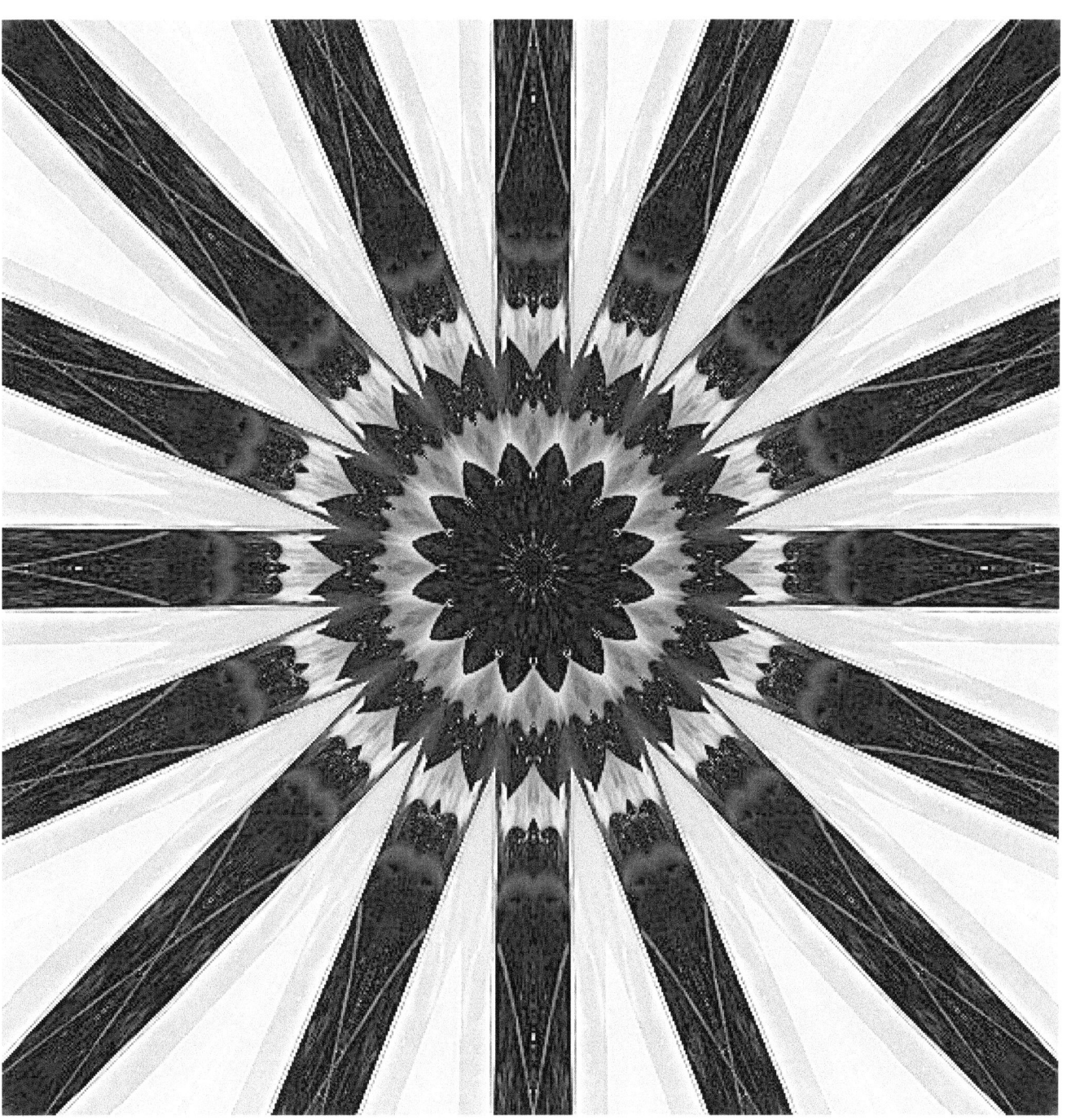

This must be the inner problem child coming out of one of our cats.
The real thing that goes bump in the night and grabs feet with sharp and pointy claws from the darkness of UNDER THE BED.

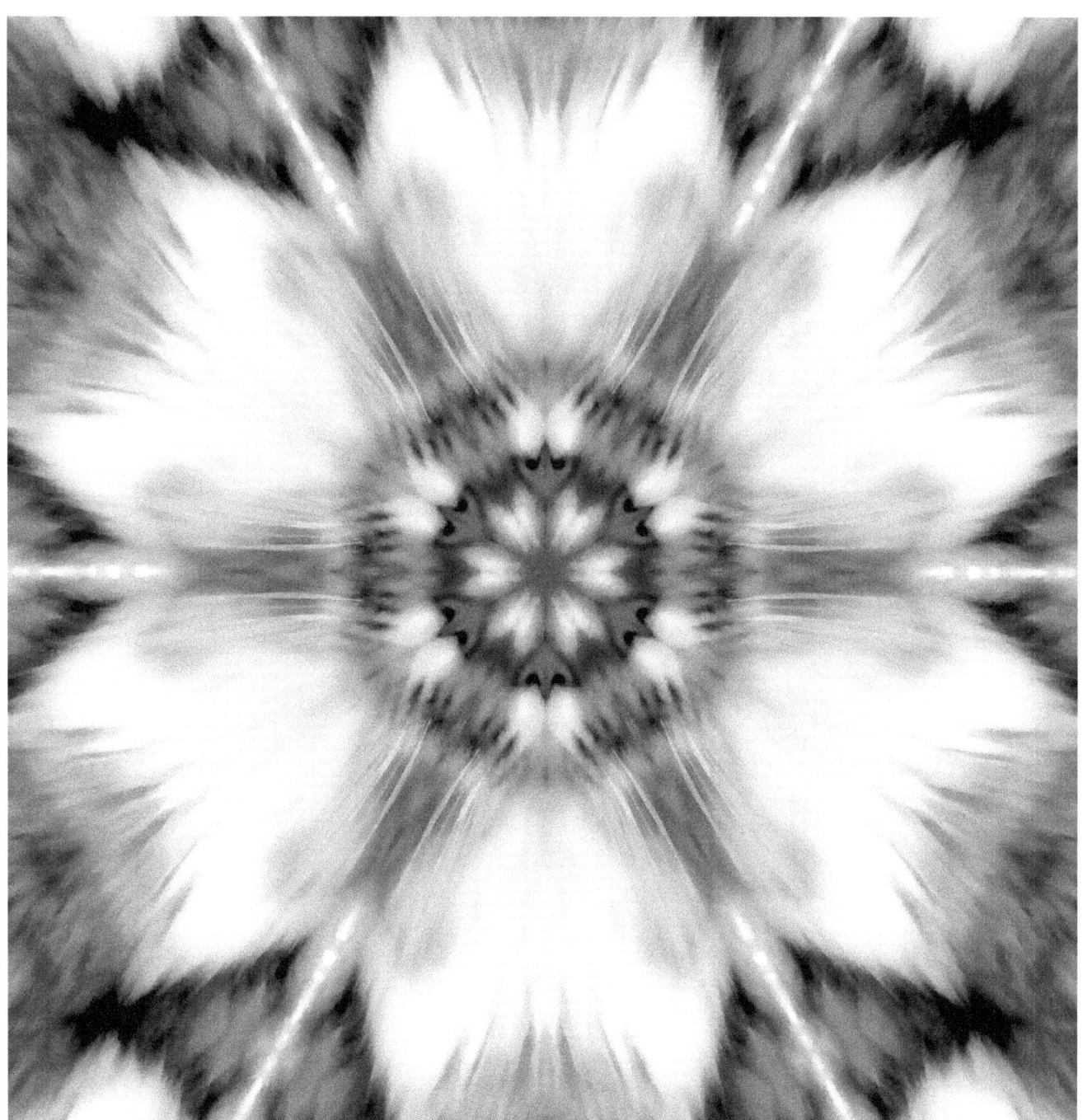

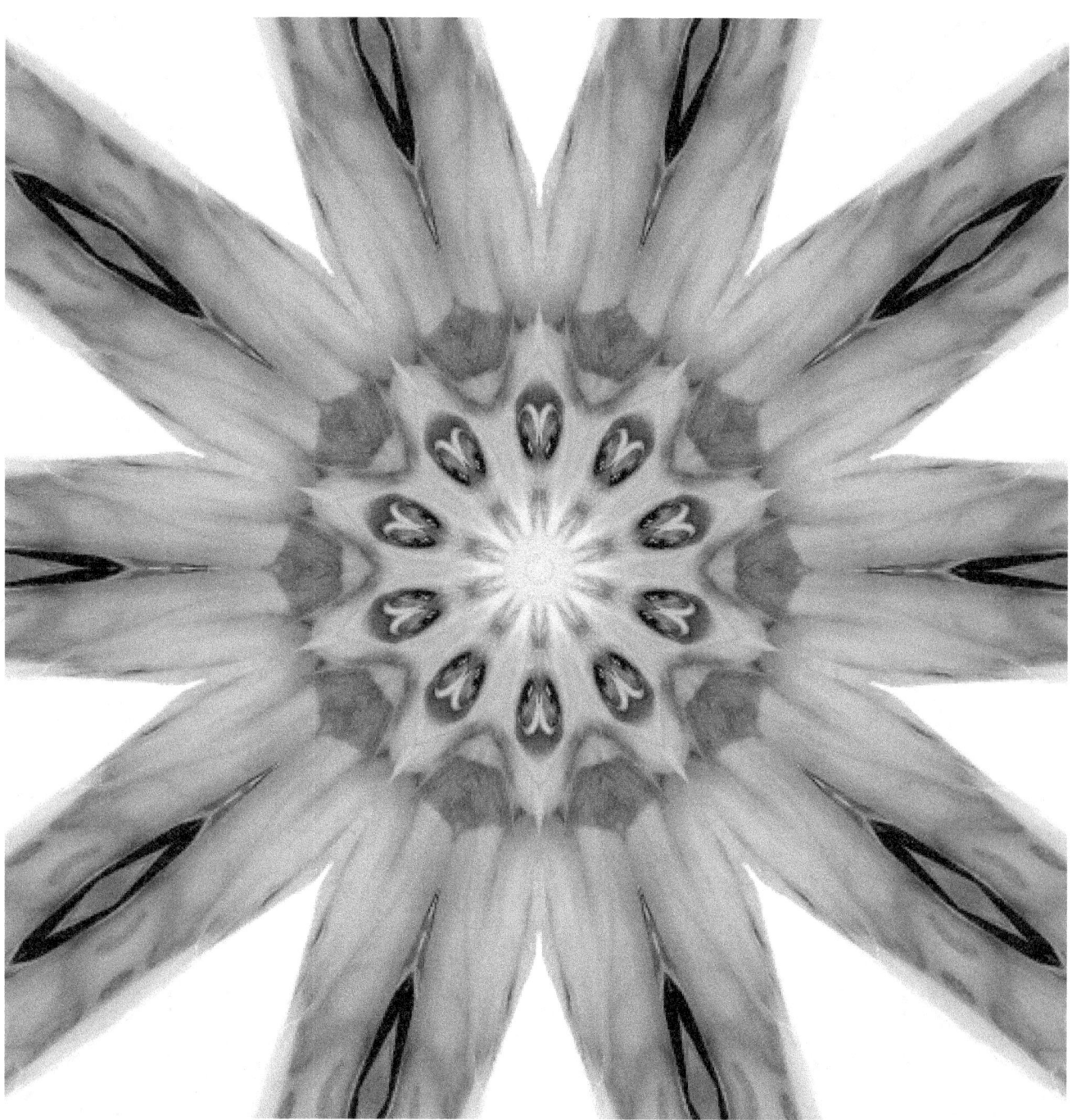

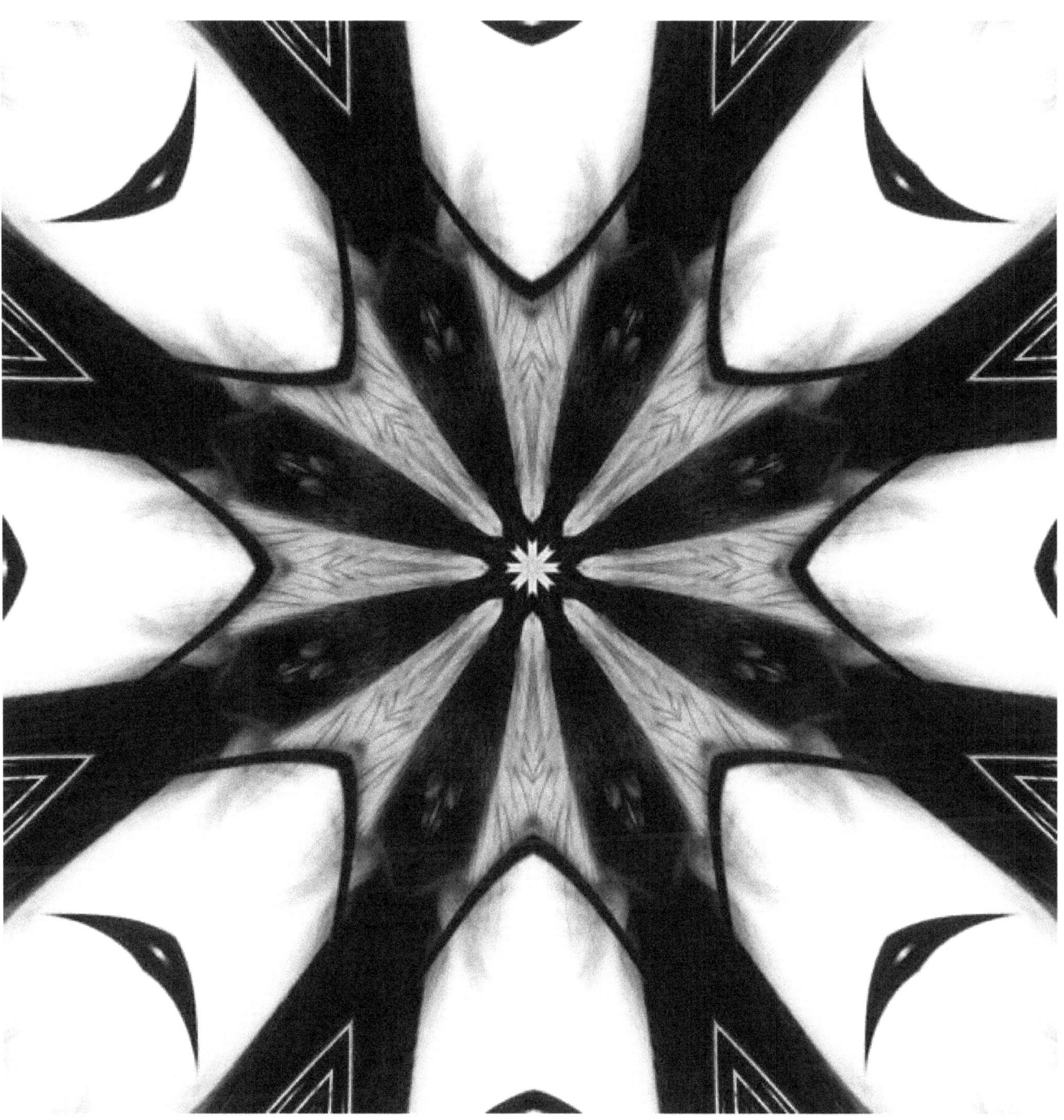

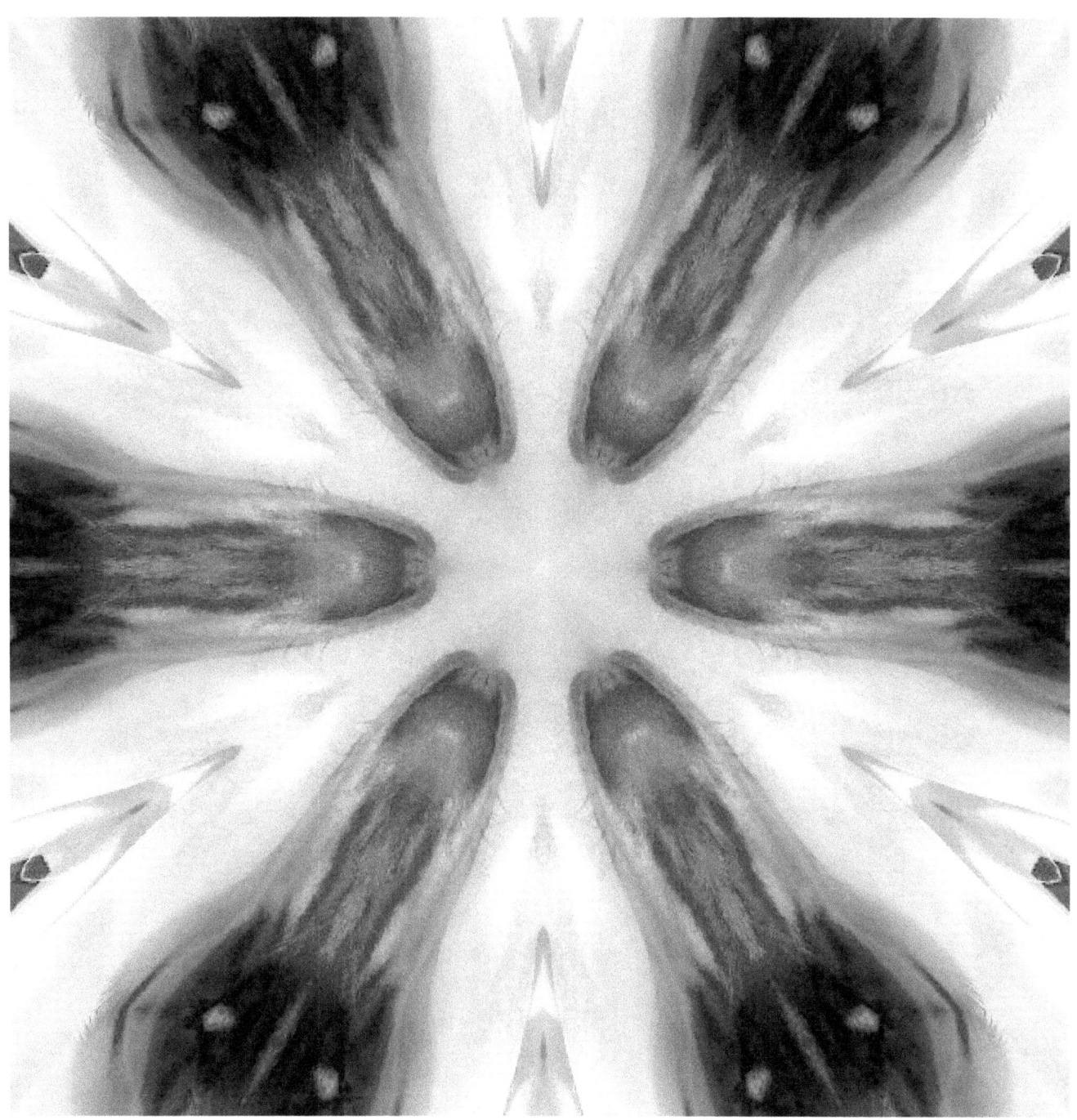

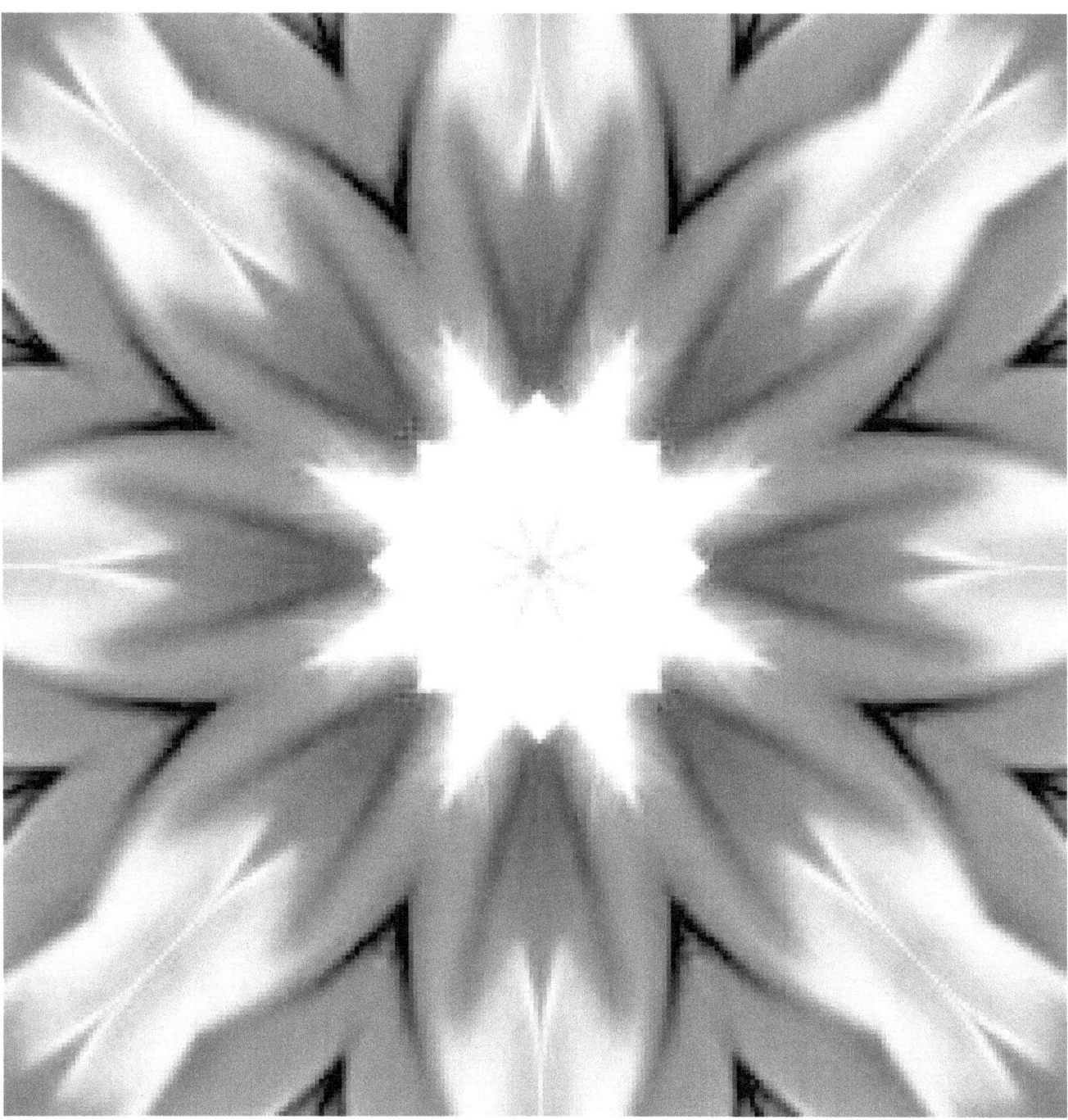

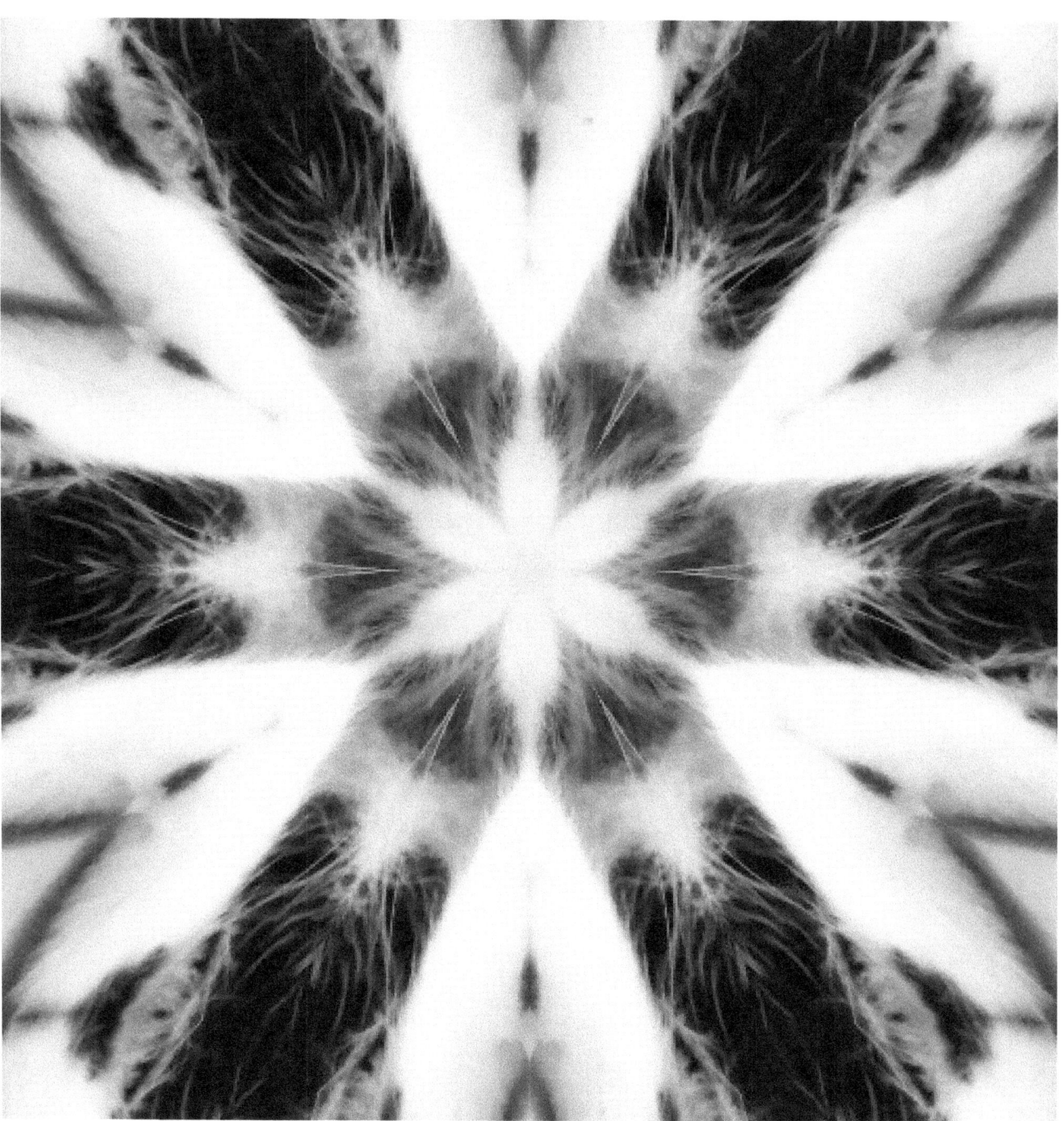

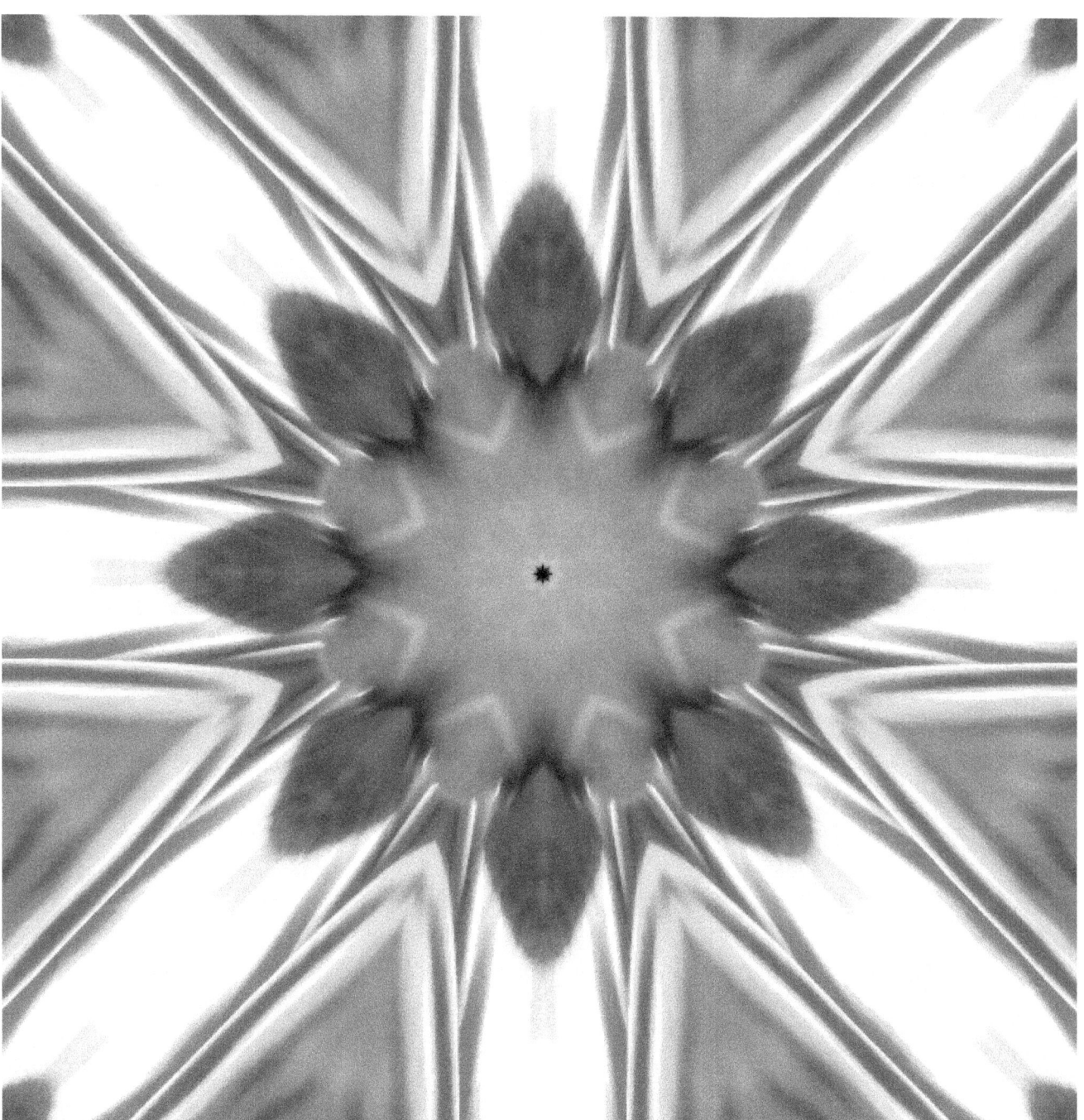

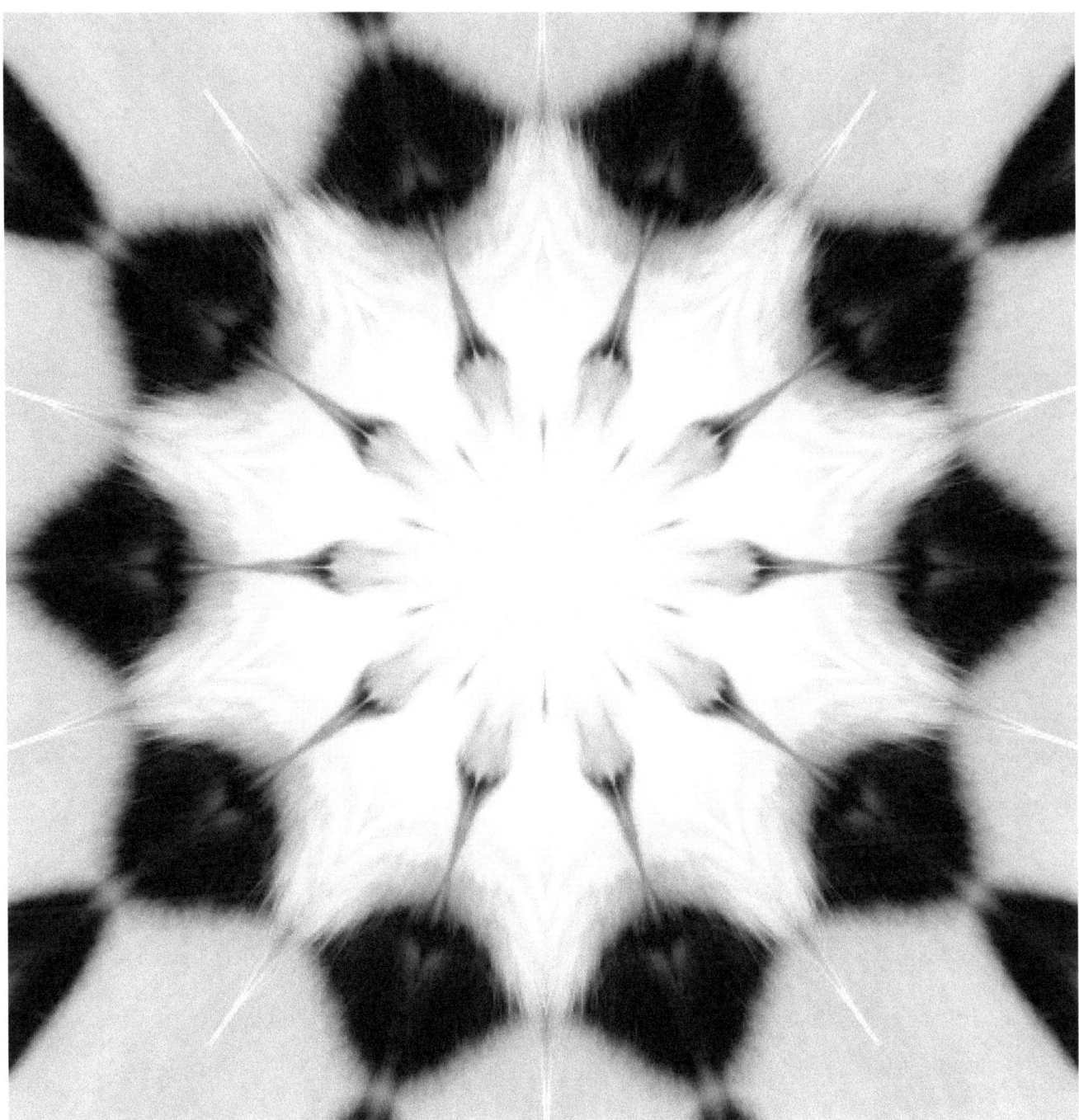

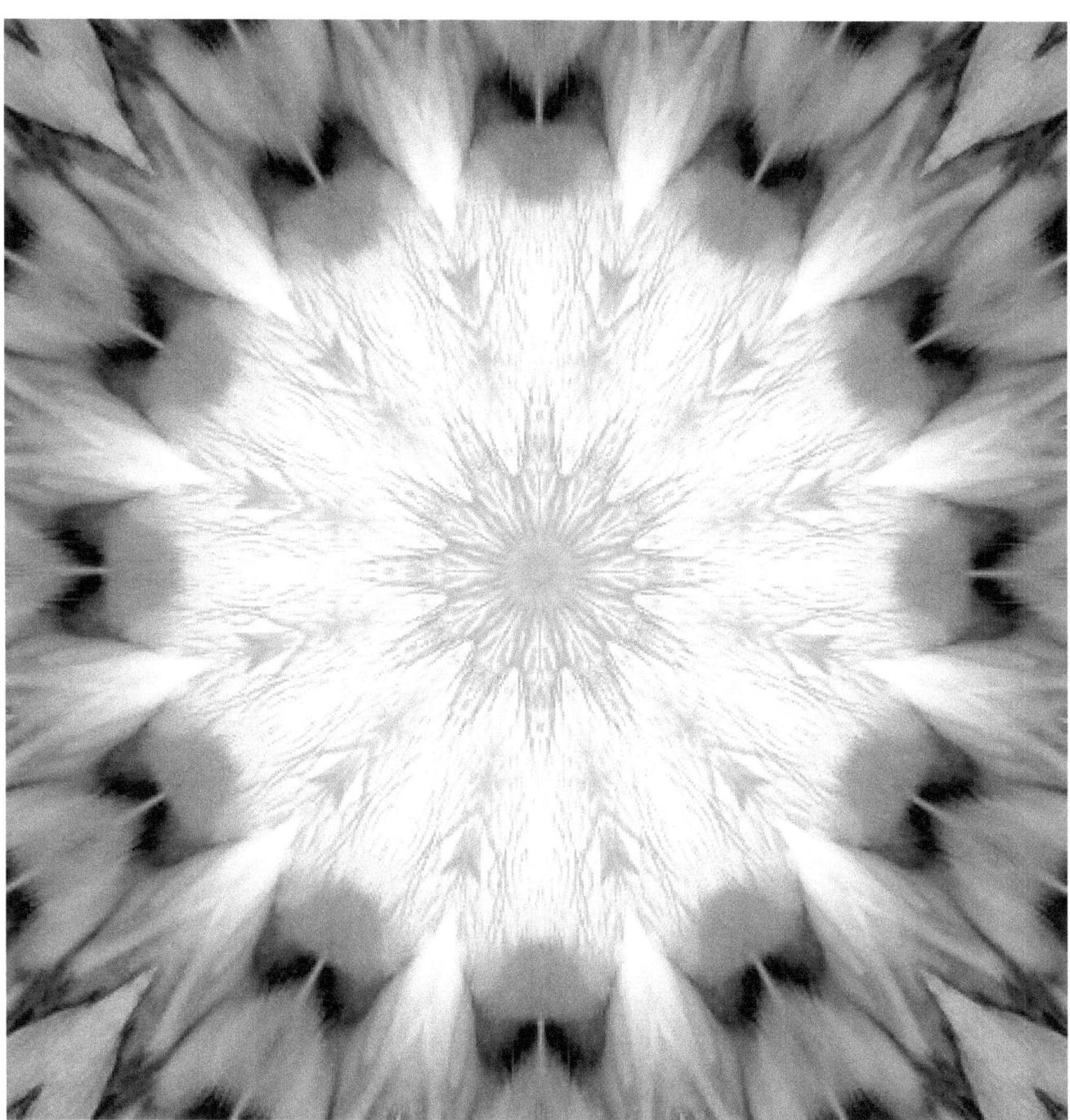

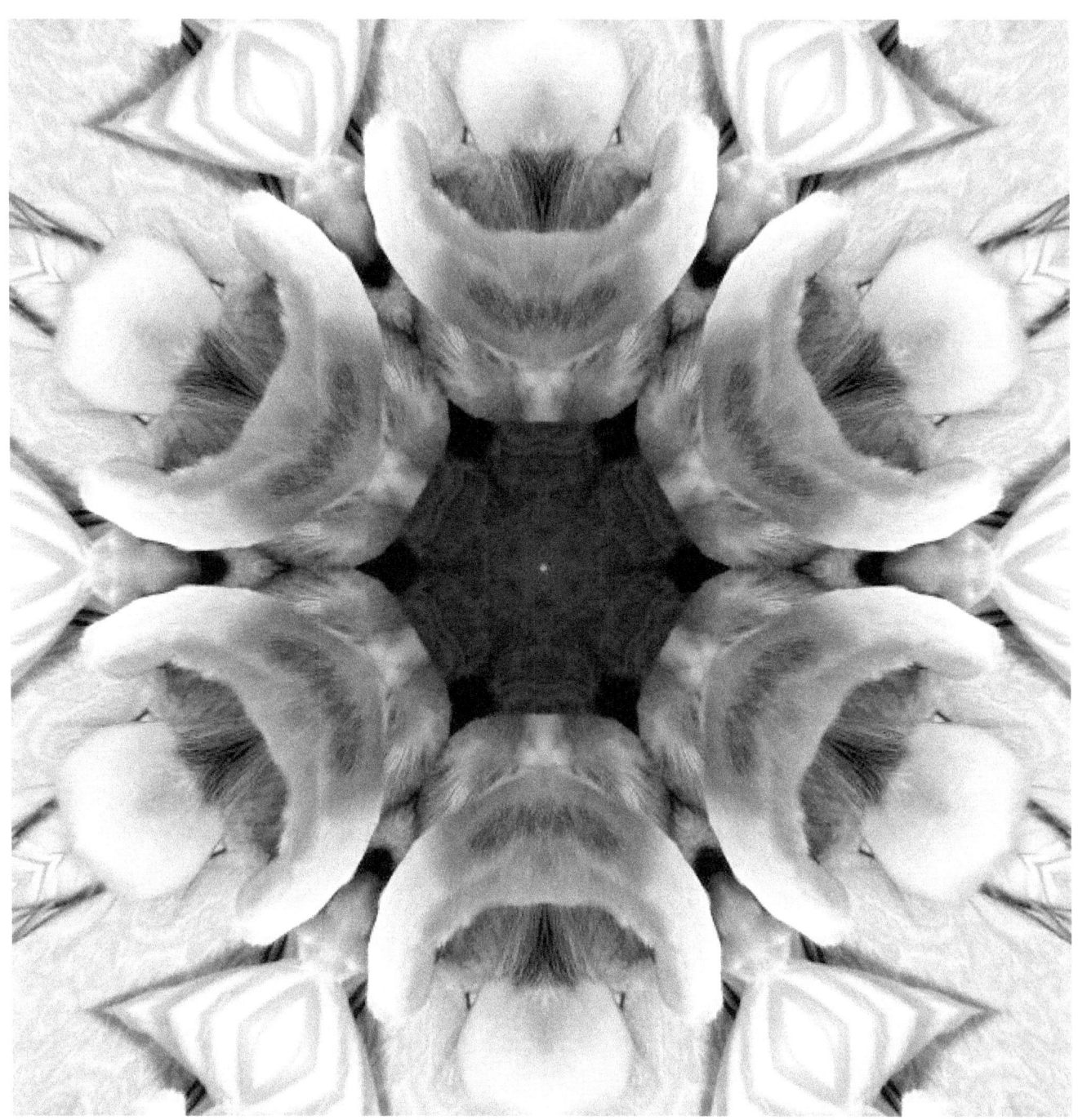

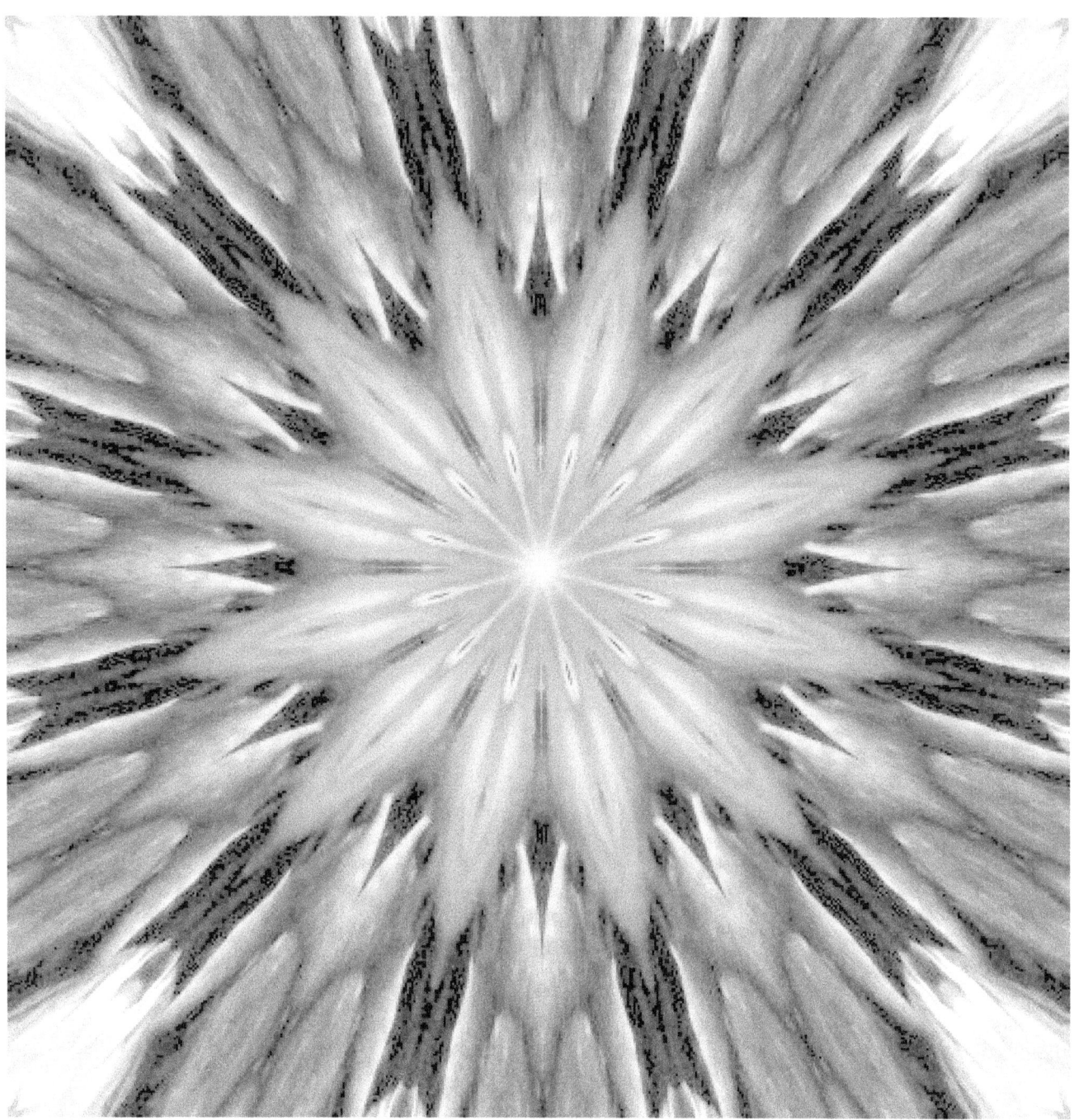

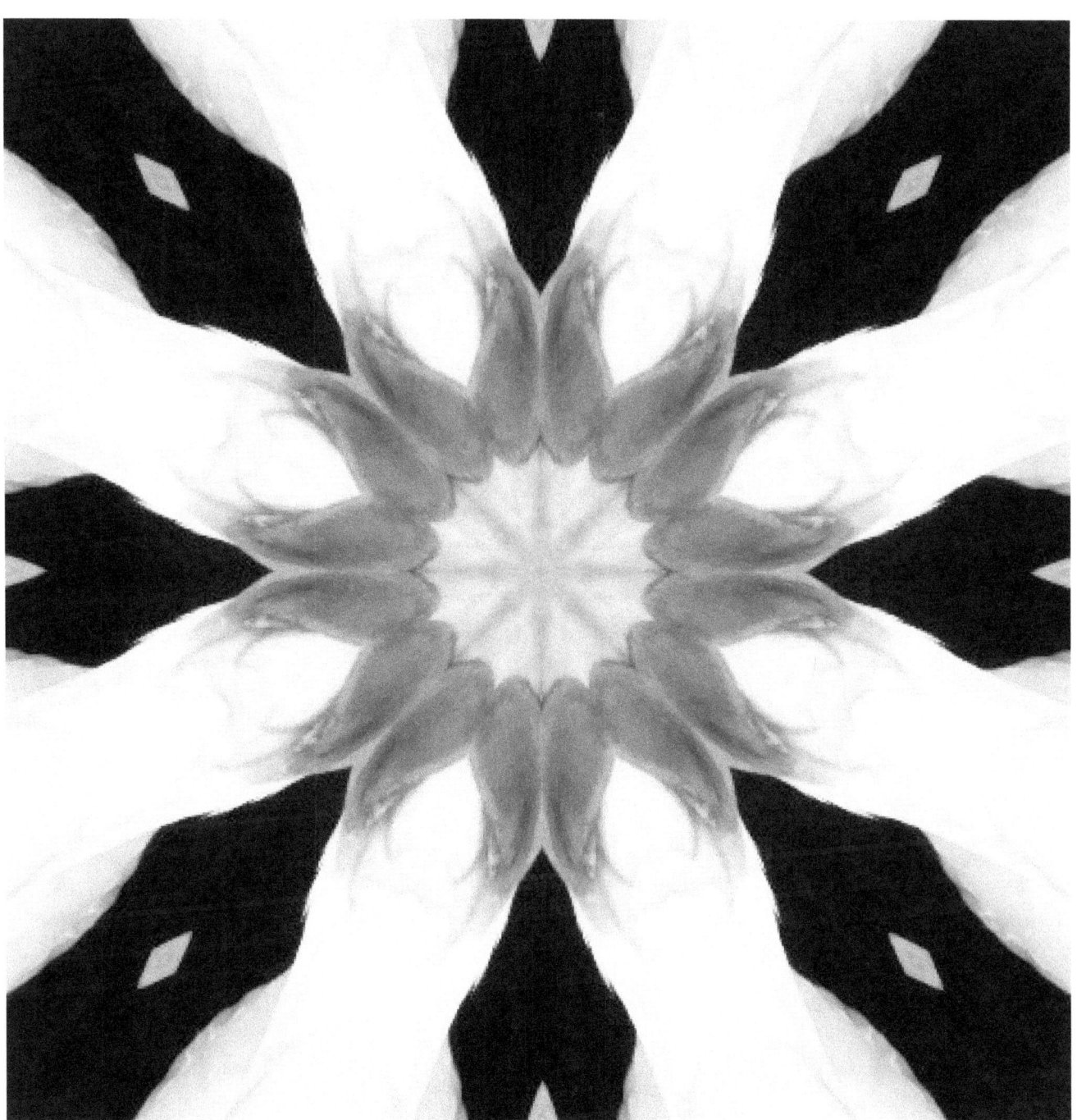

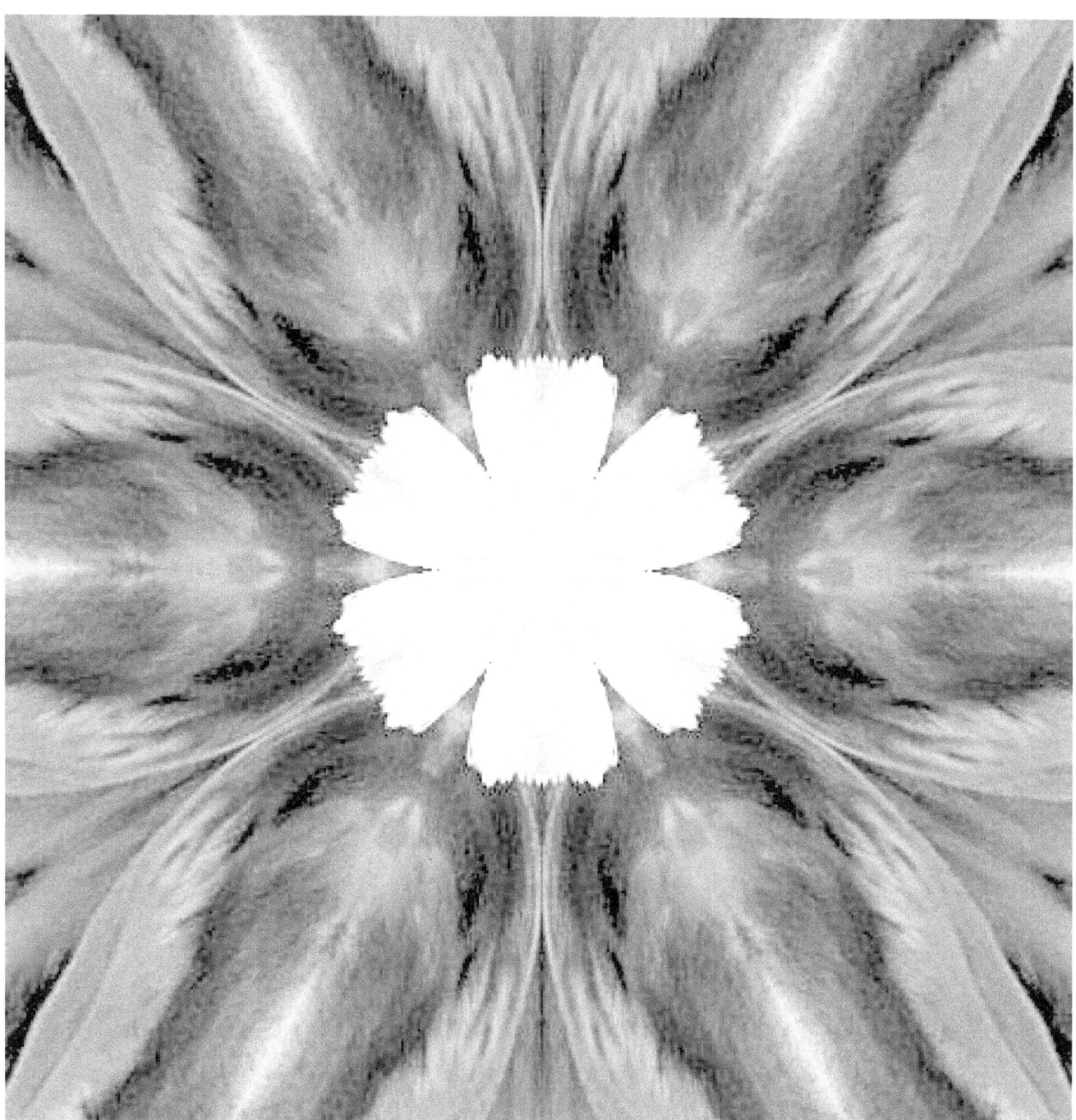

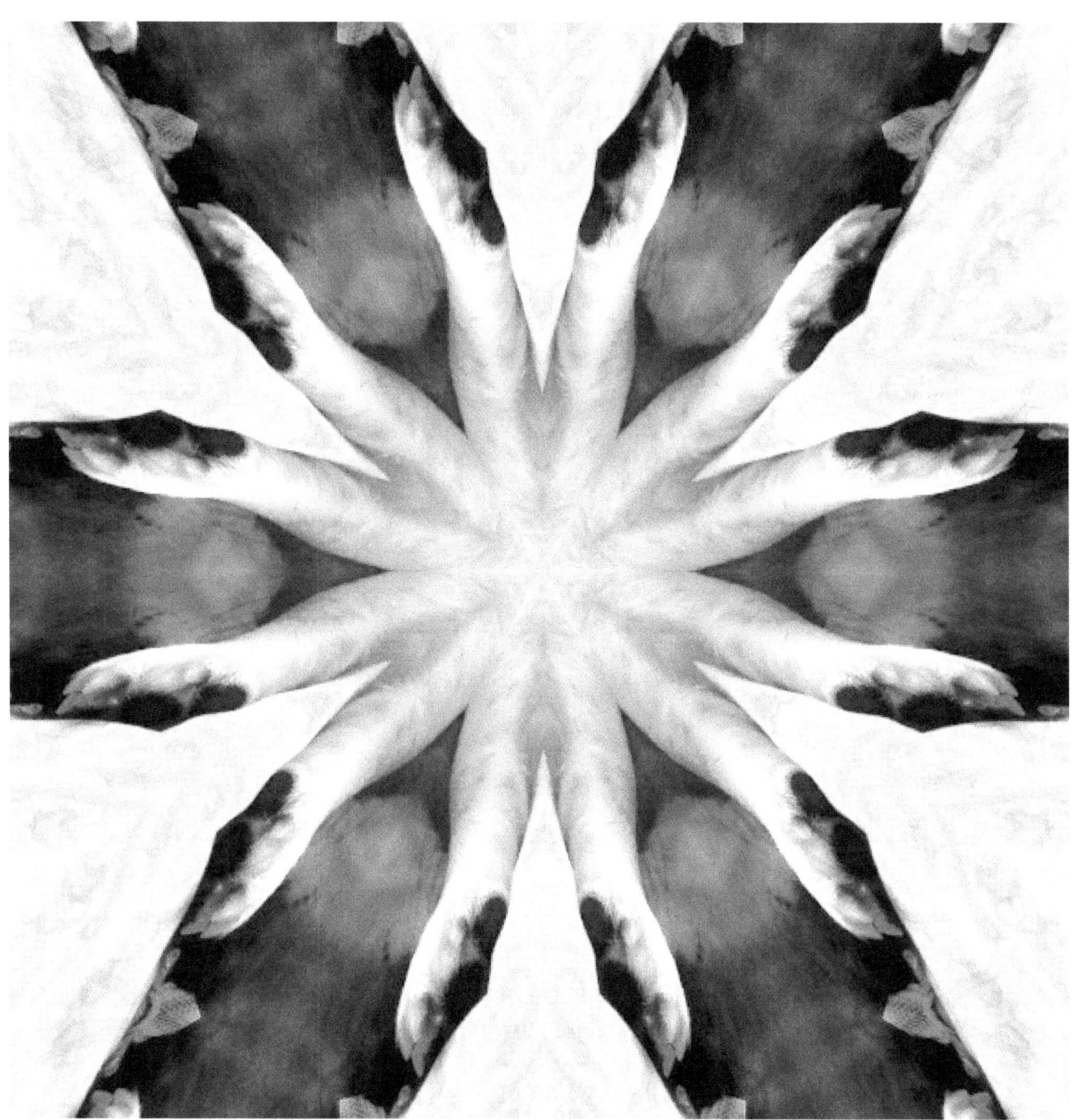

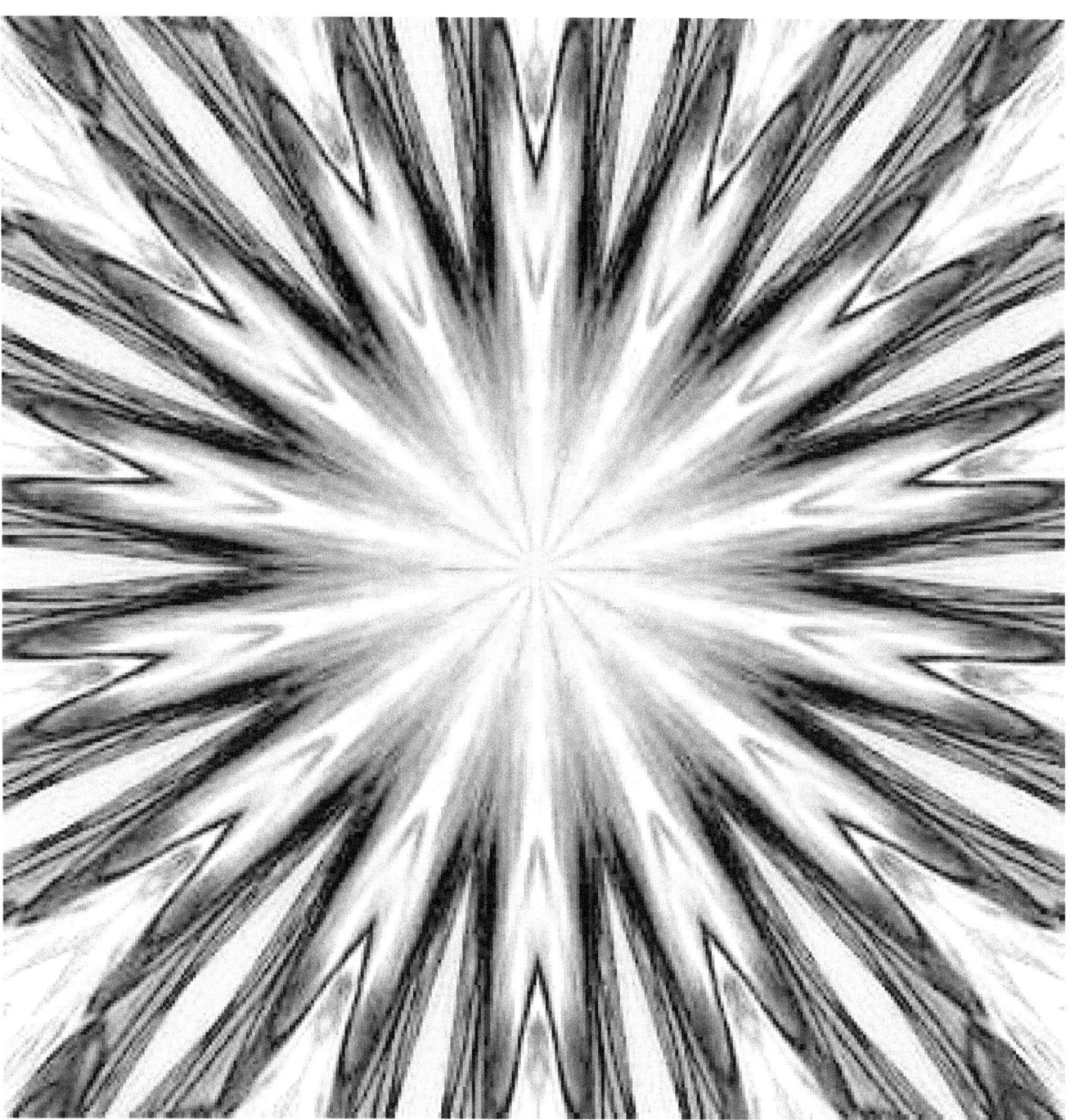

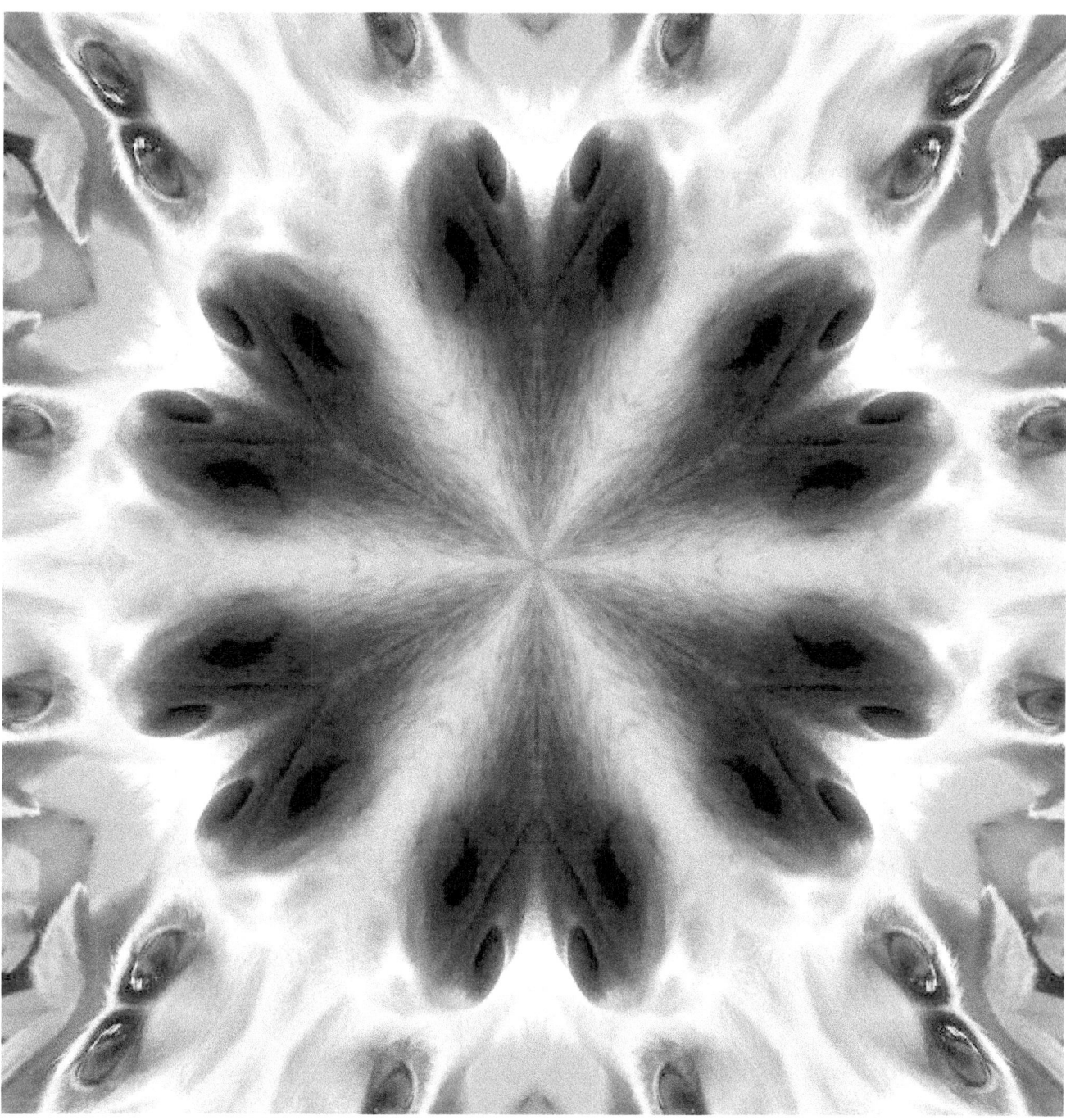

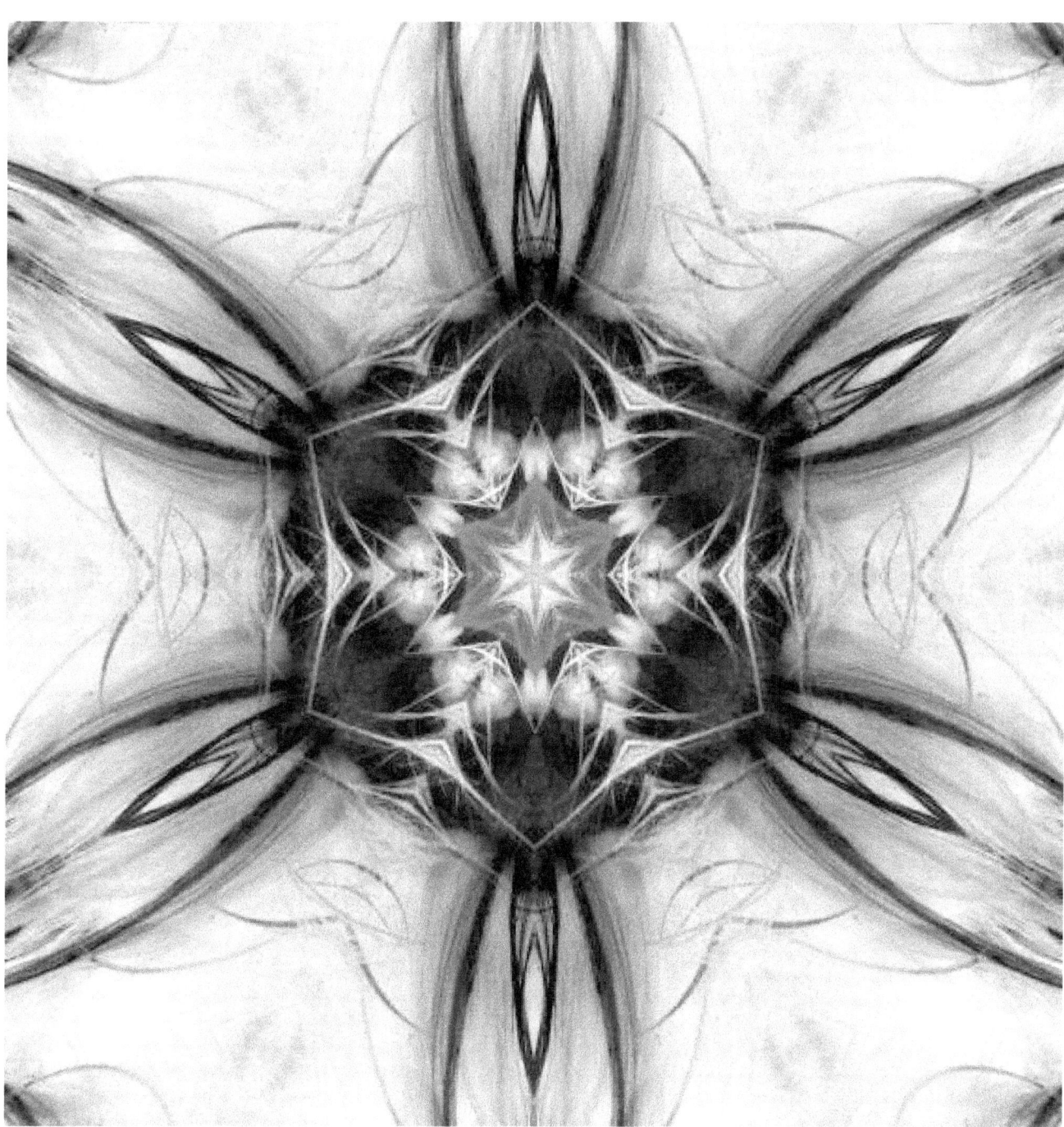

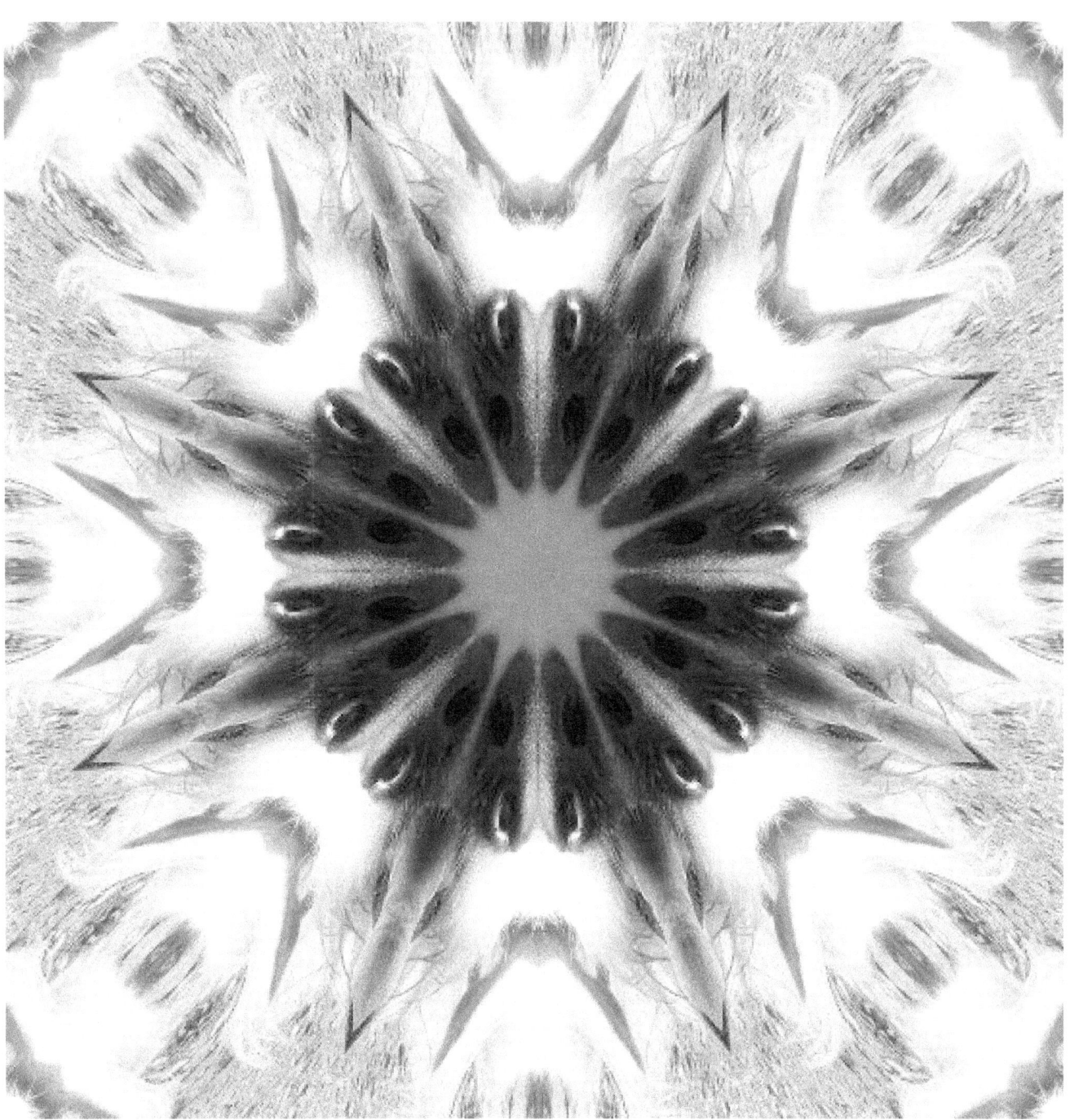

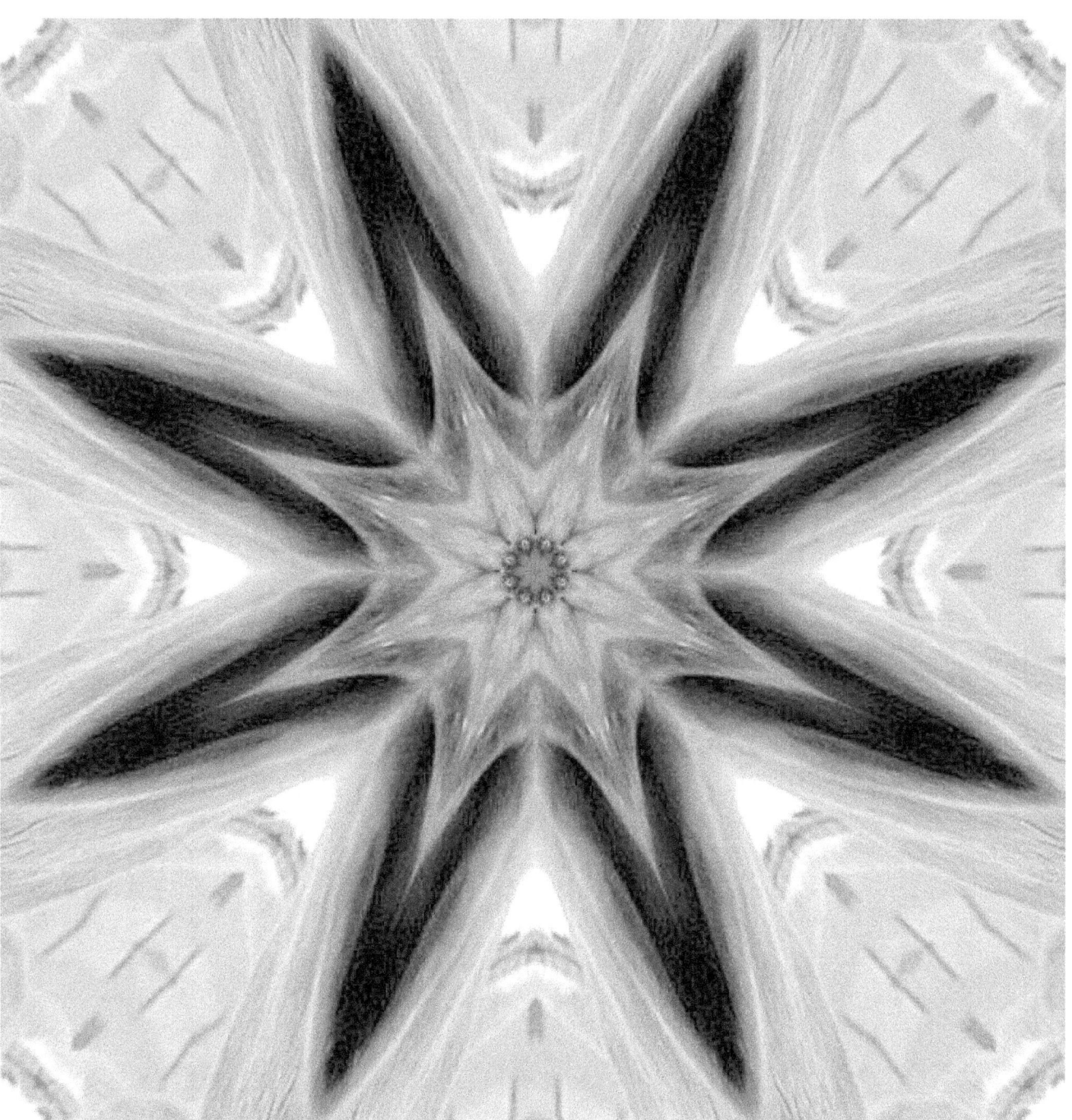

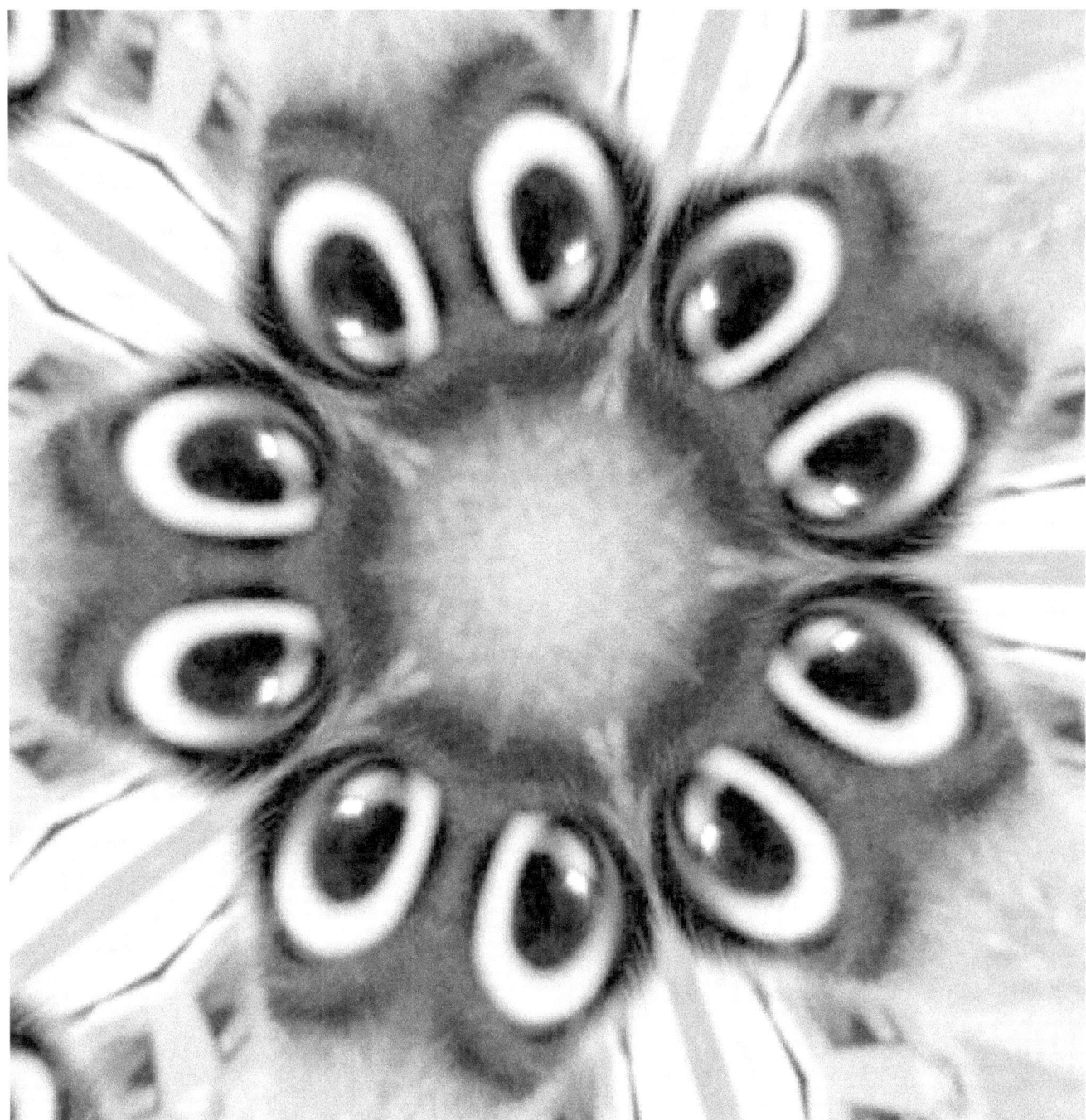

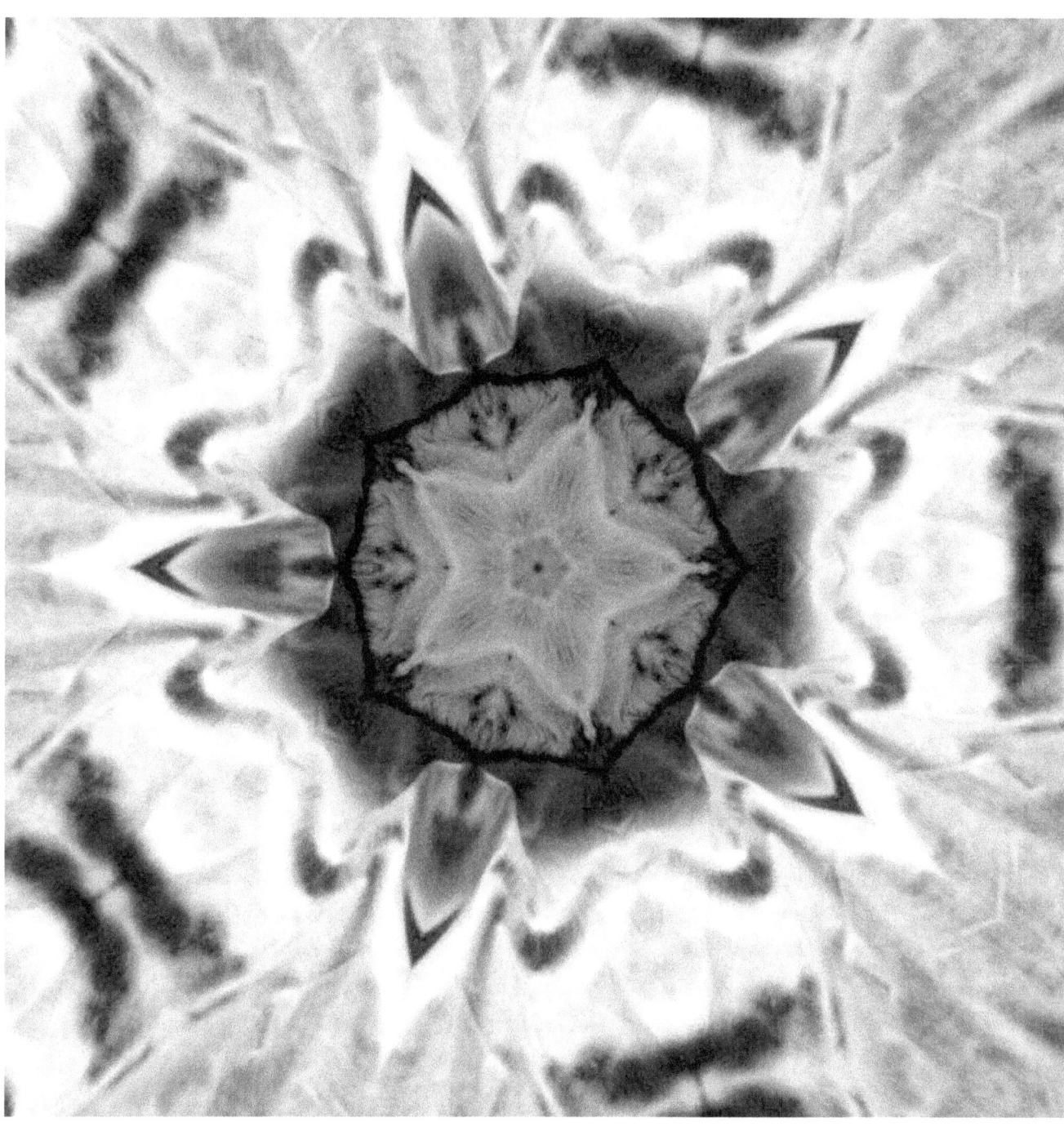

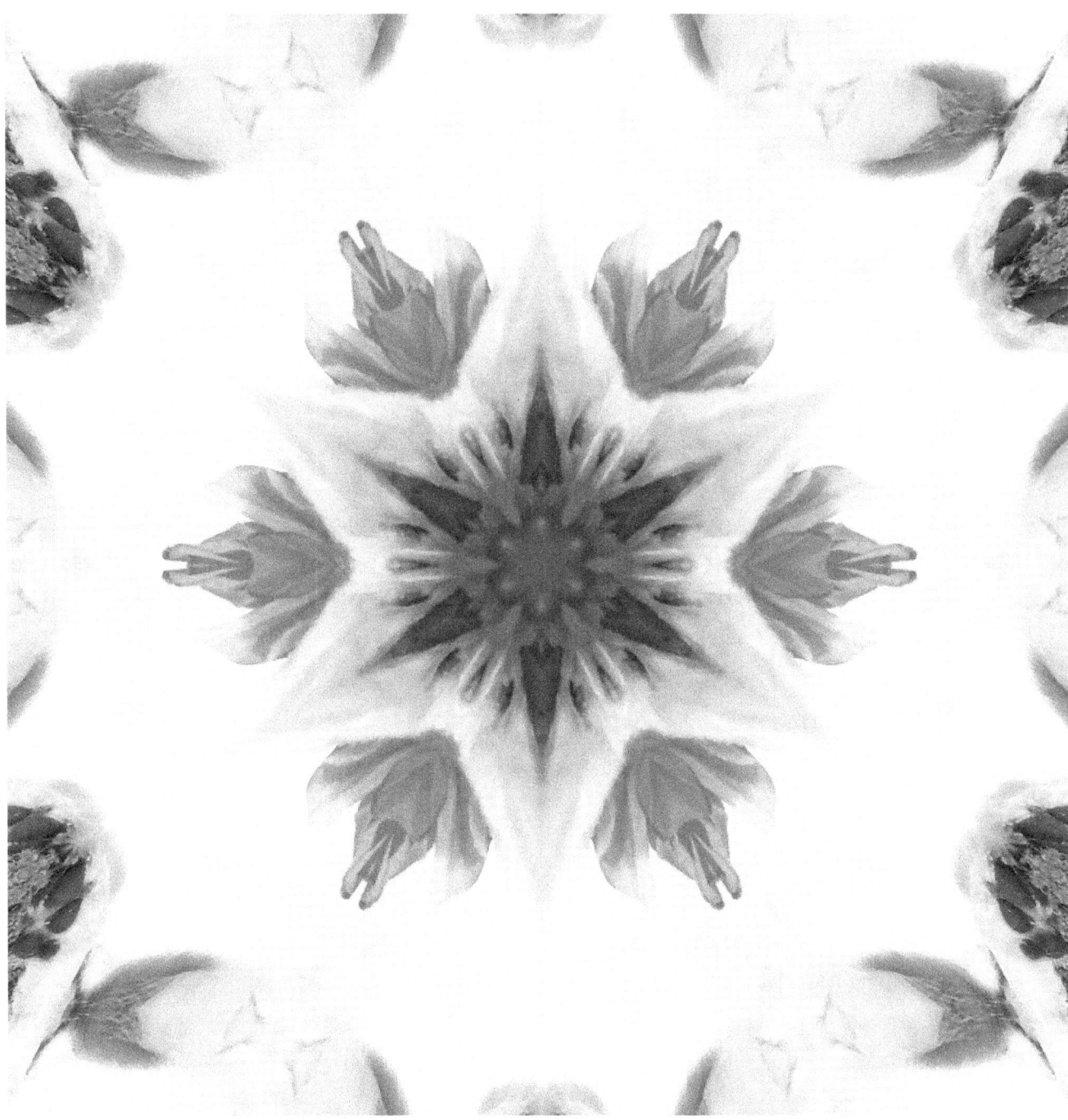

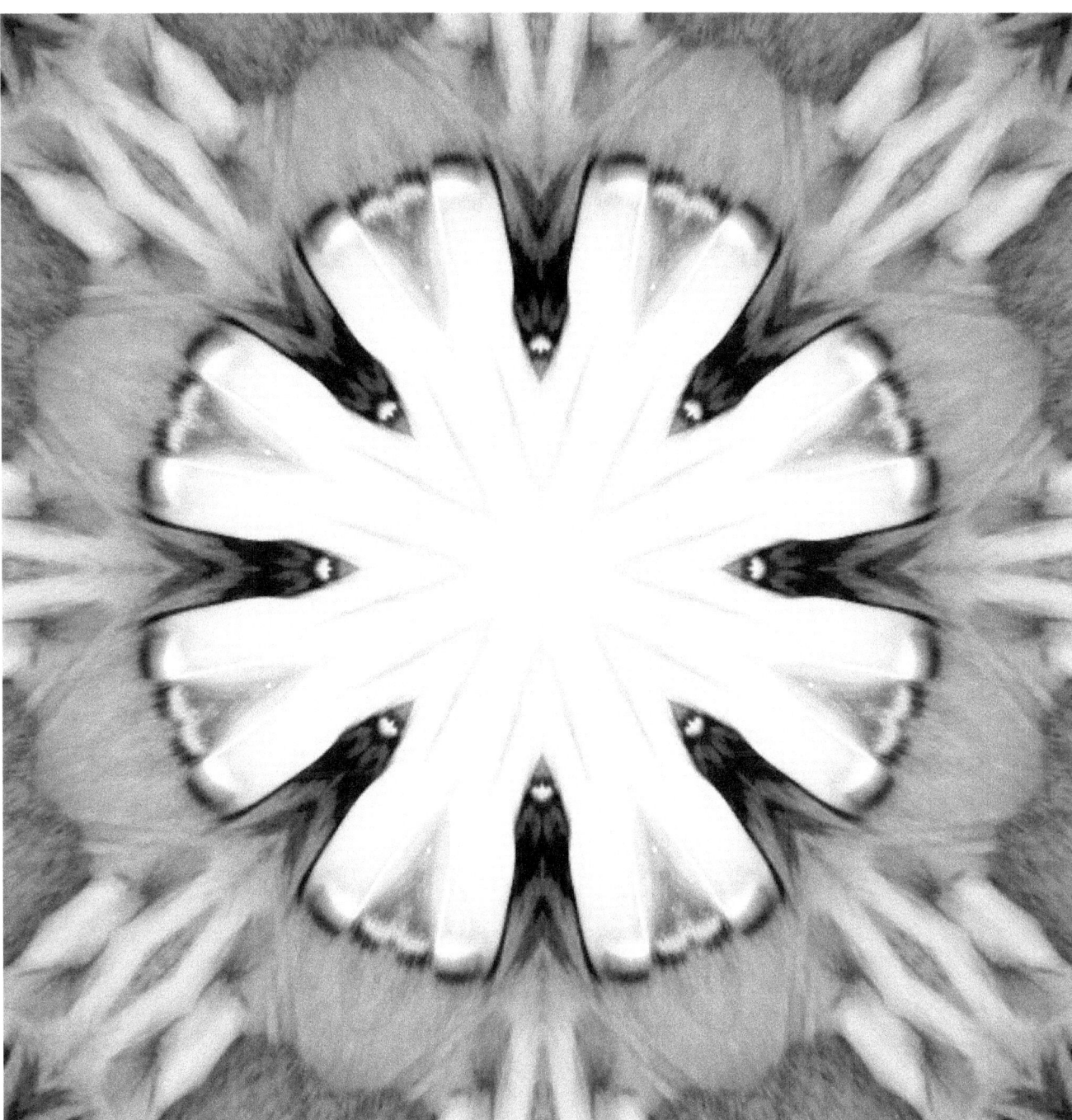

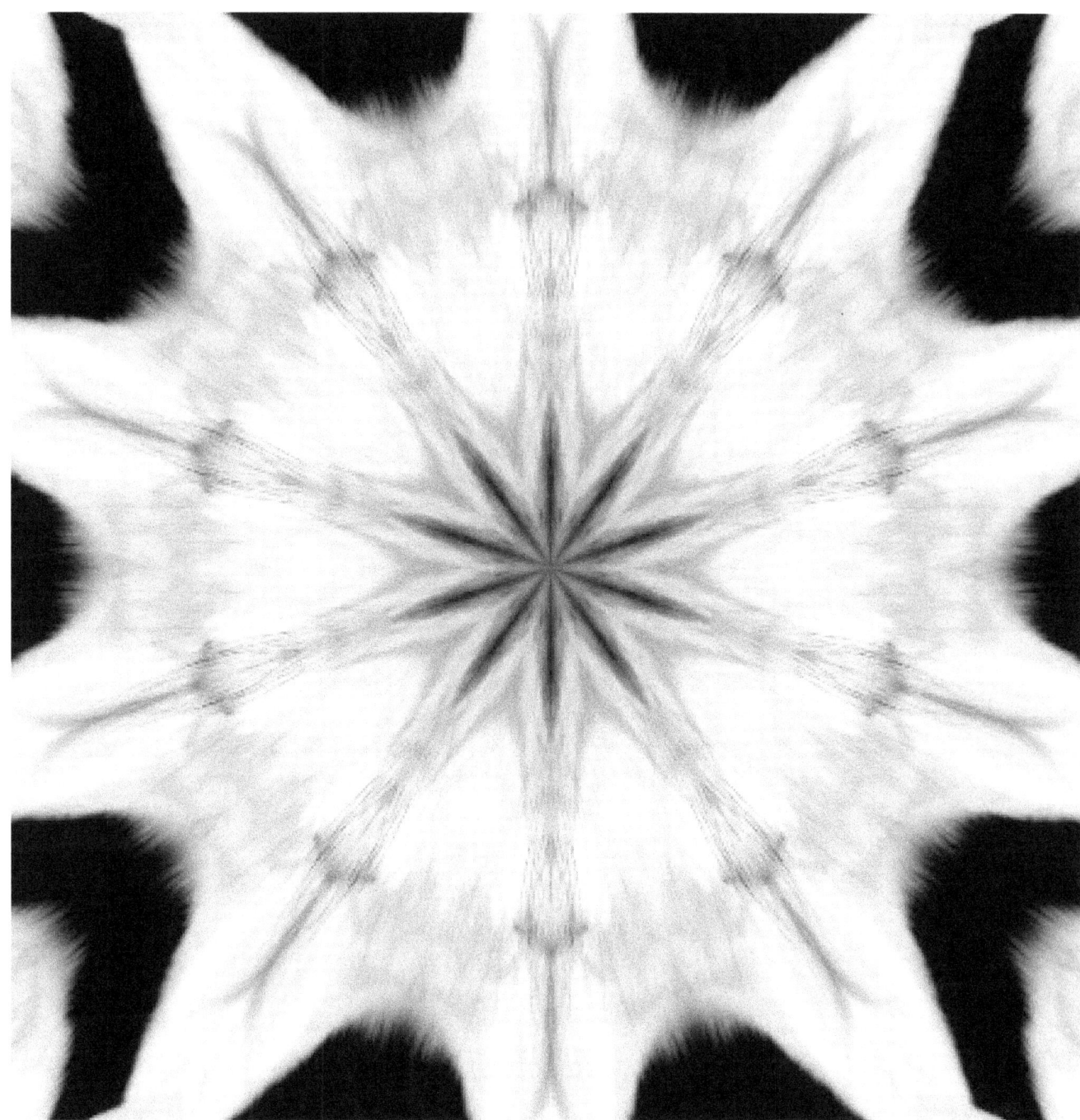

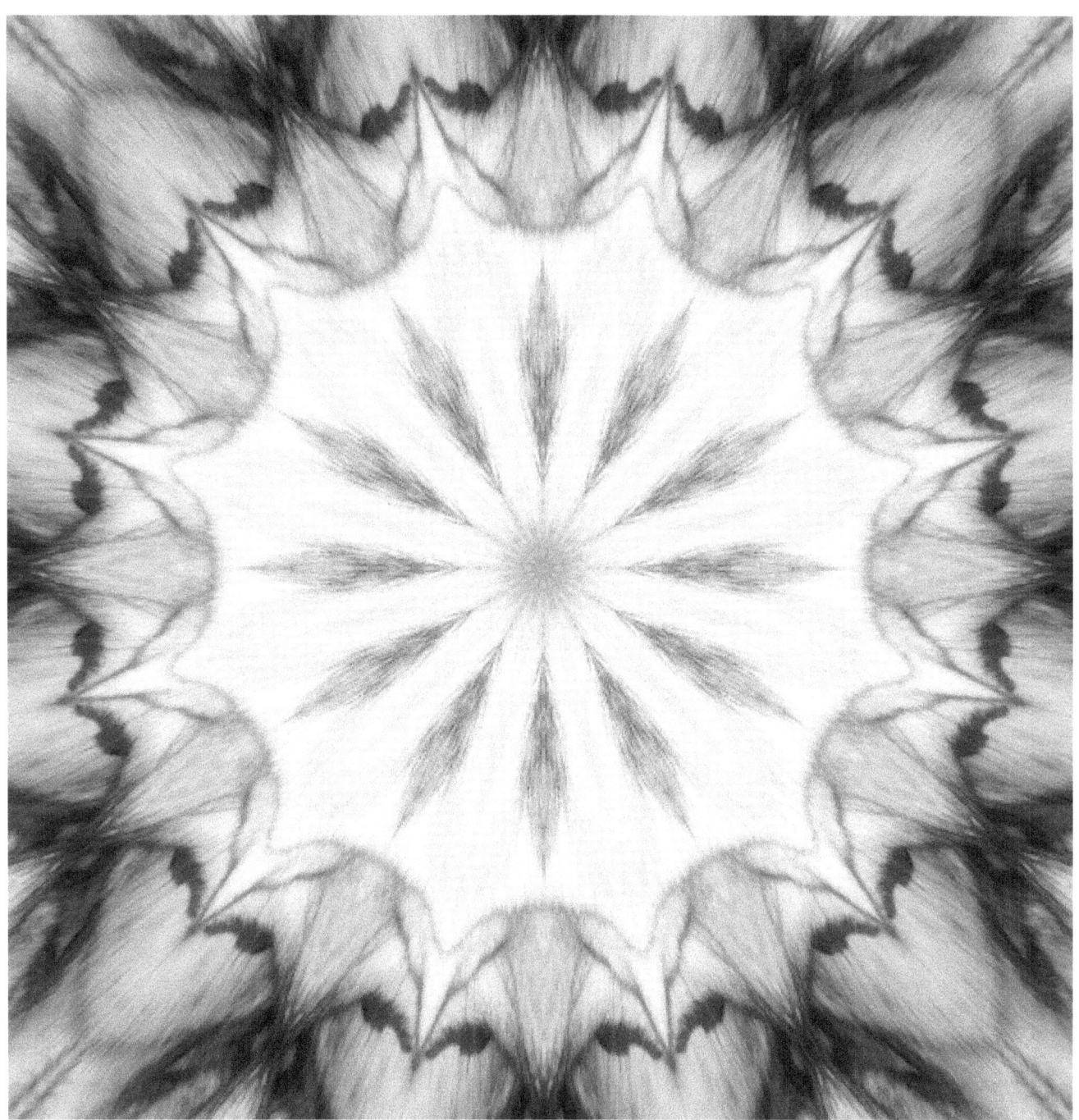

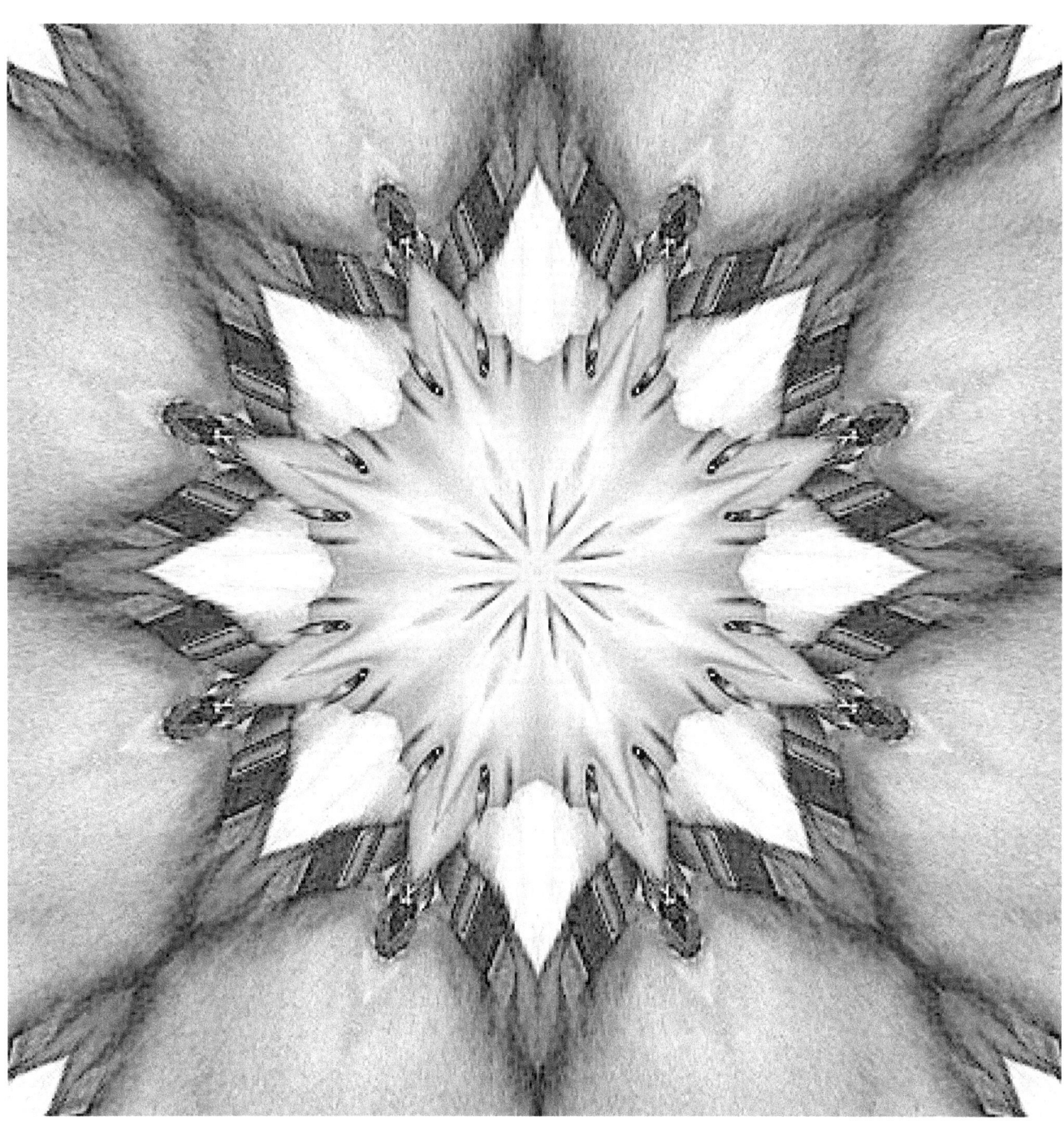

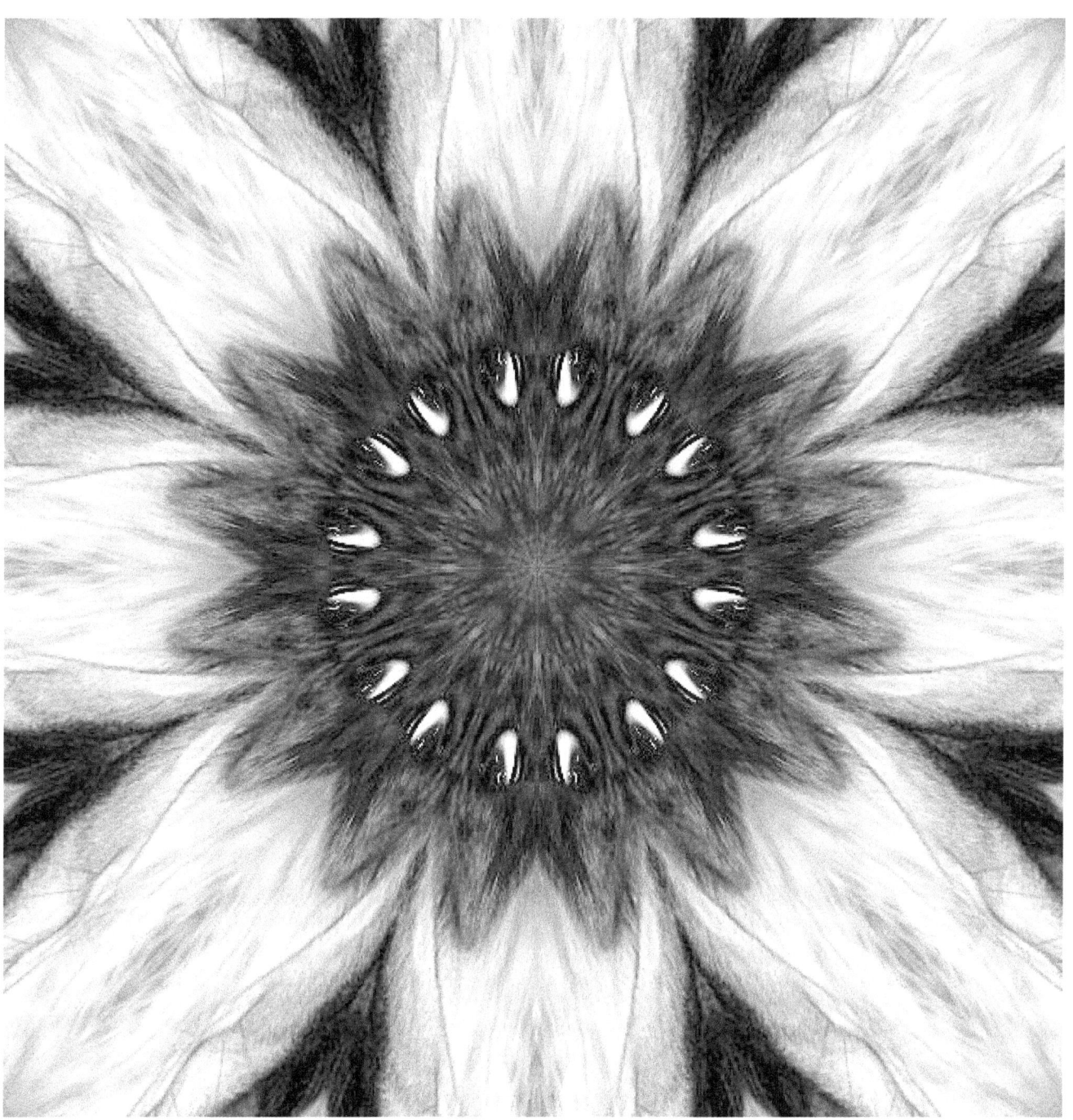

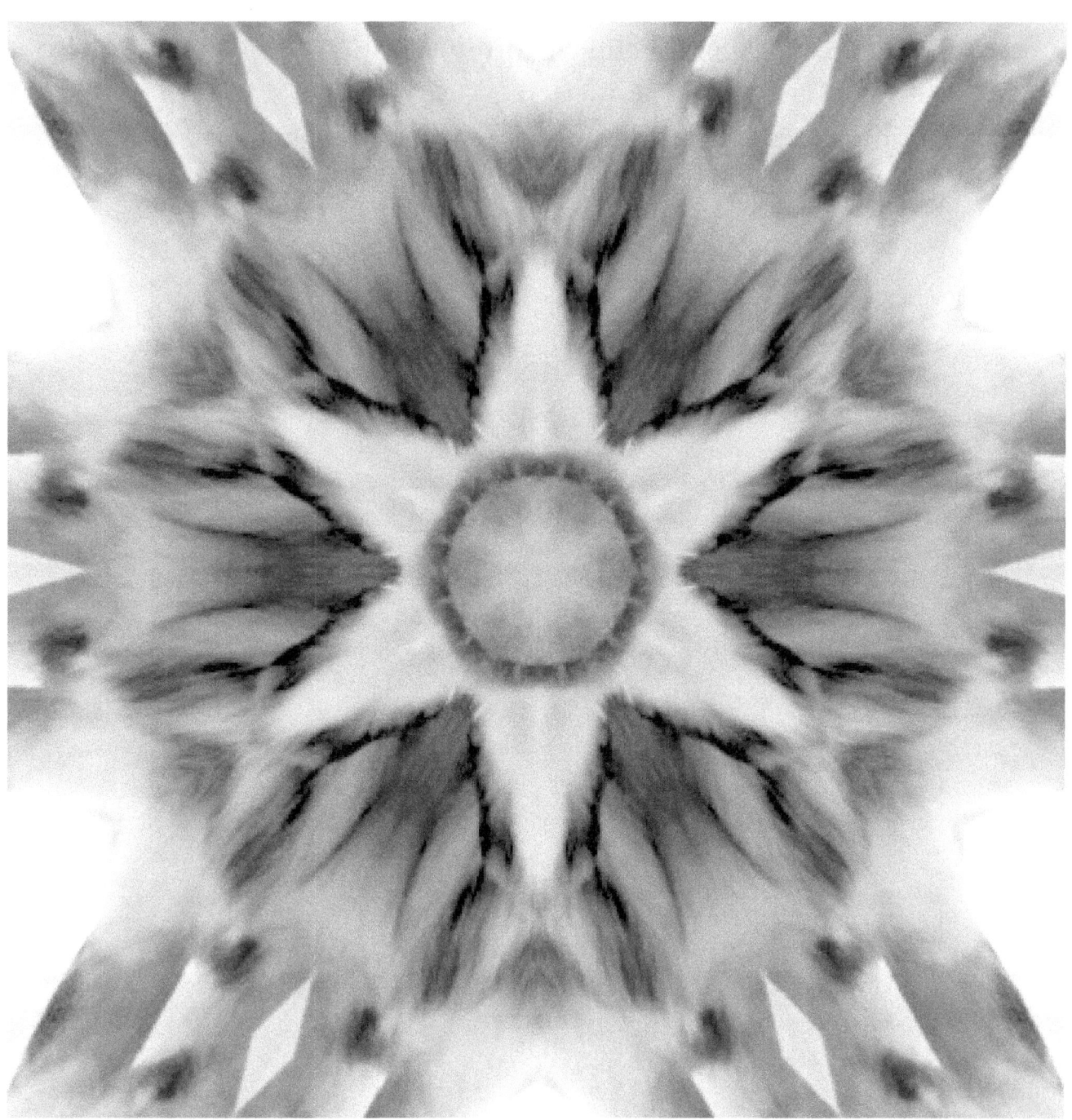

The Stars Of The Show

Sir Chauncy Tubby Wubble

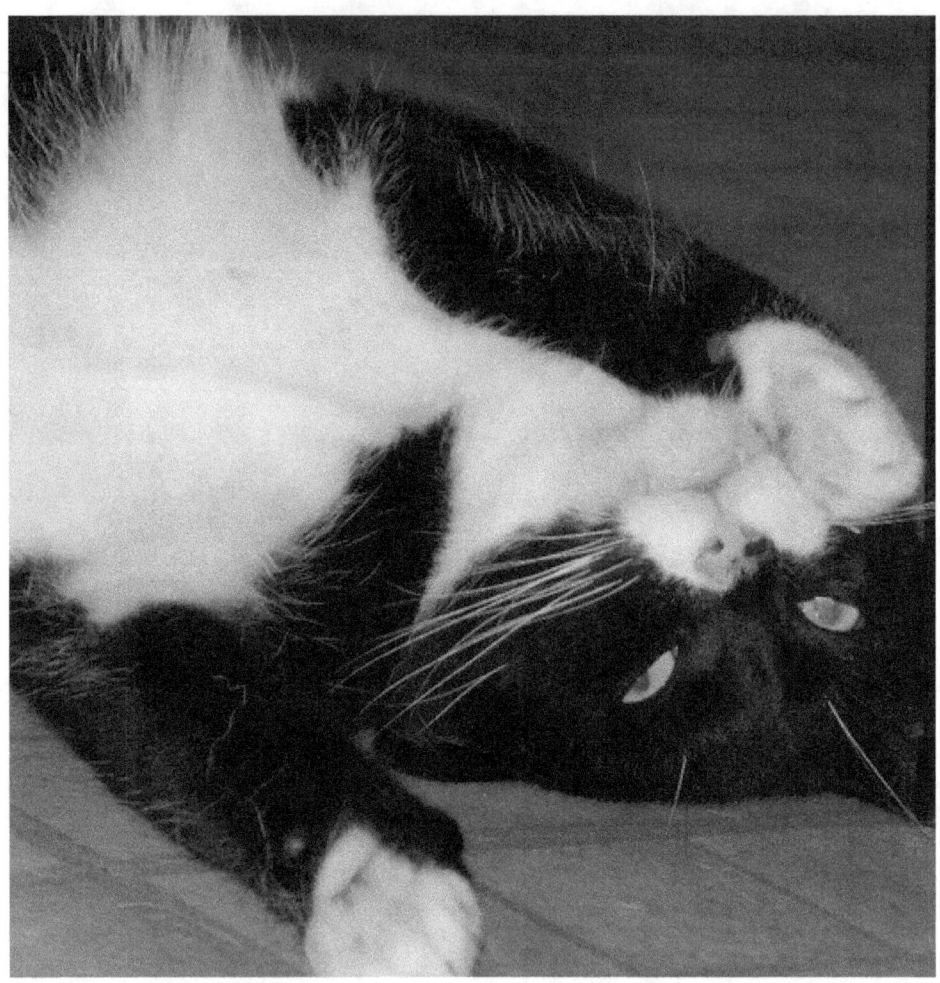

Chauncy was found by some kids in the neighborhood with his brother JiJi. The two of them were very sick, very smelly and very cute.
He enjoys cat nip and sleeping in the sun.

Jimi Guitar Hero Jimothy Johnny Jammy

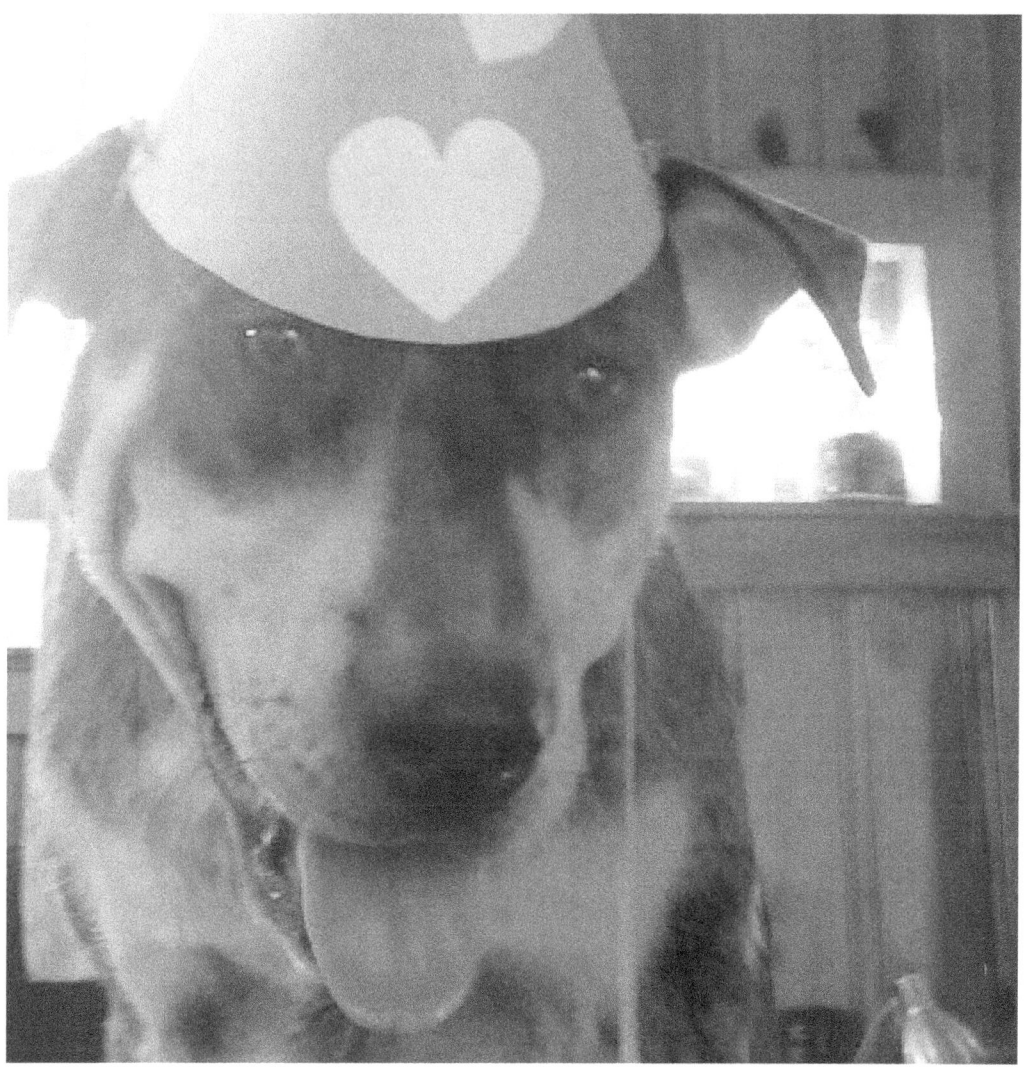

Why does Jimi have so many middle names? Because he can get into that much trouble. He is a precocious boy who has the ability to hover when he sees someone he loves using his incomparable skill as a butt wiggler. His special trick is diving under the covers and playing Bed-Shark. He also "gets spots" like a cat and believes lasers come out of fingertips. Jimi is very colorful, much like his namesake, and occasionally models clothing. Here he shows off a custom party hat.

Potato (or Gran'potato, Tater or Toots)

Potato joined our family many years ago from The Westerly Pound in RI. He is a big goofy guy and acts as the grandfather to the sickly animals that come to the door.
He likes to steal food from your hand while you are looking away so cookies and crackers need to be eaten immediately by the human. Although his hips are getting stiff, he still loves to frolic and bound after toys.
His favorite hobbies are wiping his wet beard on unsuspecting people and showing how good he is at shaking hands with extreme exuberance.

Pickle Tufty Toes Nekkid Belly

Pickle found our home one evening and came in as a skeletal, flea covered kitten. She has since grown into a beautiful 13 pound cat. Pickle uses her fluffy tail to collect dust bunnies from under the beds. She loves to attack the carpet.

Too Cute Caarrll

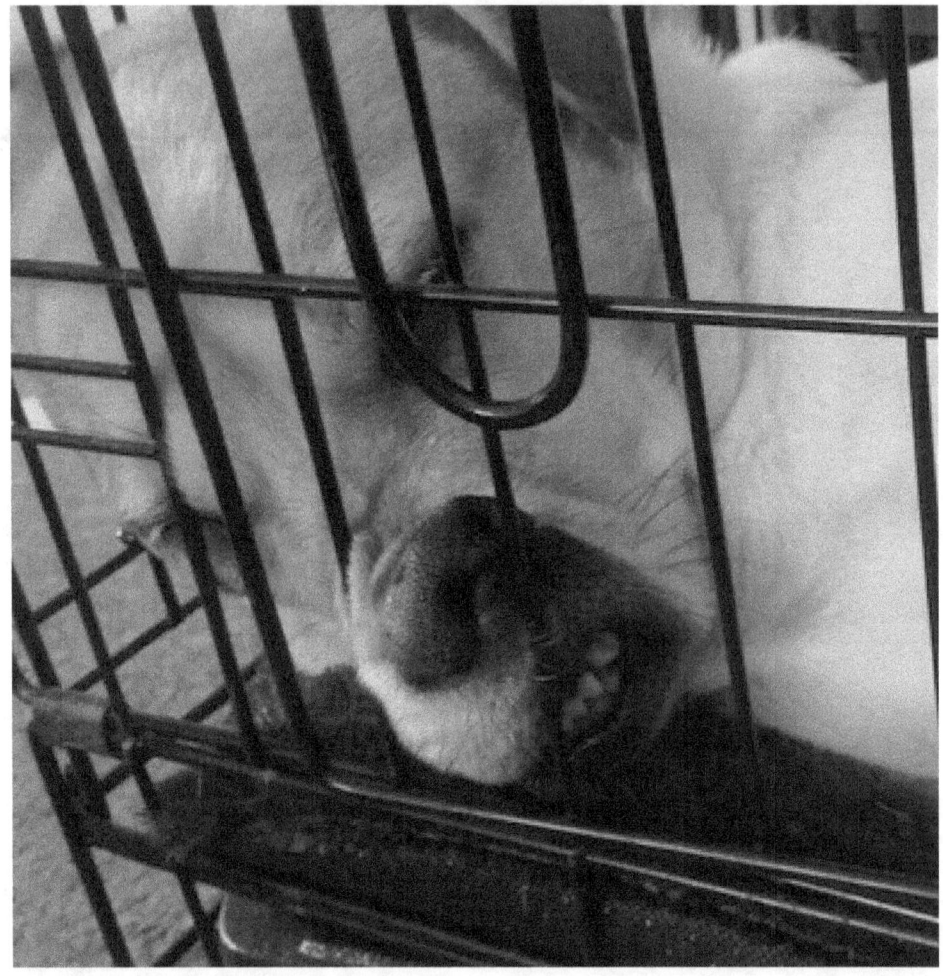

Caarrll did not approve of Dr ordered bed rest so he had to plant his face firmly into the corner of his crate for pity. Pancreatitis and ACL problems are no fun to get better from, but he made it through unscathed.
His signature walk is the Prancing Wiggle Bottom. He is also a serial fuzzy blanket nurser.

ABOUT THE AUTHOR

Erika grew up with sand and sun in her hair in Narragansett, RI. Ever the adventurer and all around tiny animal finder, her interest in the small details and the humble parts of nature took hold.

She was set up on a blind date at 17-years-old where she found her husband. They raised three children in Groton, CT where their home was surrounded with woods and streams which helped nurture their kids' interest in nature.

Erika's background includes working as a CNA, MA(AAMA), and as a medical transcriptionist - which she enjoyed until she was replaced by a dragon.

Her continued love of nature, gardens, Beale Street Music Festival and her pets compels her to take far too many photos, some of which she would like to share.

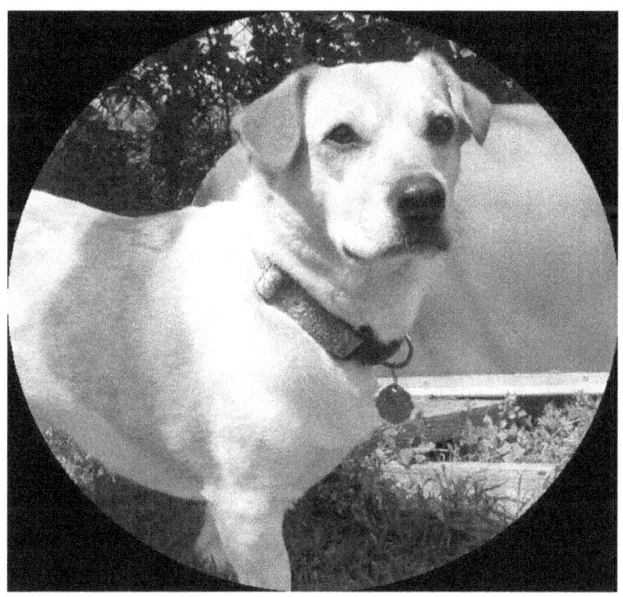

A far better photo of Caarrll.
He really is cute and does not continually smash his nose into the corner of his crate.
He normally sleeps on my pillow or tucked under the blanket.

www.ingramcontent.com/pod-product-compliance
Lightning Source LLC
Chambersburg PA
CBHW080704190526
45169CB00006B/2233